Barbara Hepworth

Barbara Hepworth

Penelope Curtis

ST IVES ARTISTS

Tate Publishing

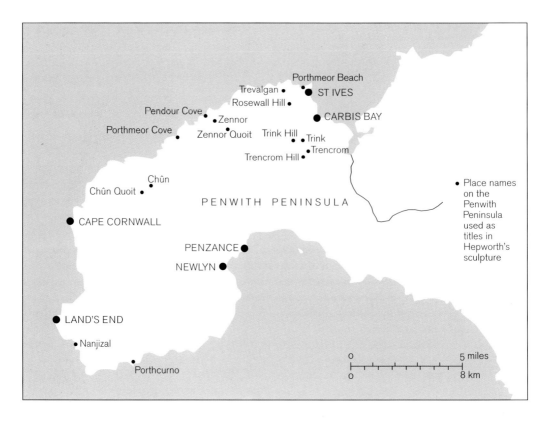

Map of the Penwith Peninsula showing: Porthmeor Beach, Trevalgan, ST IVES, Rosewall Hill, Pendour Cove, Zennor, CARBIS BAY, Porthmeor Cove, Zennor Quoit, Trink Hill, Trink, Trencrom, Trencrom Hill, Chûn, Chûn Quoit, PENWITH PENINSULA, CAPE CORNWALL, PENZANCE, NEWLYN, LAND'S END, Nanjizal, Porthcurno

• Place names on the Penwith Peninsula used as titles in Hepworth's sculpture

0 5 miles
0 8 km

COVER: *Forms in Movement (Galliard)* 1958 (fig.40)

FRONTISPIECE:
Barbara Hepworth in June 1971

First published in 1998 by order of the Trustees of the Tate Gallery. Reprinted 2001, 2002, 2004 by Tate Publishing, a division of Tate Enterprises Ltd, Millbank, London SW1P 4RG
www.tate.org.uk/publishing

British Library Cataloguing in Publication Data
Curtis, Penelope
 Barbara Hepworth. – (St Ives artists)
 1. Hepworth, Barbara, Dame, 1903–1975 – Criticism and interpretation 2. Sculpture, English
 I. Title II. Tate Gallery
 730.9'2

ISBN 1 85437 225 4

Cover designed by Slatter-Anderson, London
Book designed by Isambard Thomas

Printed in Hong Kong by South Seas International Press

St Ives Artists

The light, landscape and working people of West Cornwall have made it a centre of artistic activity for over one hundred years. This series introduces the life and work of artists of national and international reputation who have been closely associated with the area and whose work ca be seen at Tate St Ives. Each author sets out a fresh approach to our thinking about some of the most fascinating artistic figures of the twentieth century.

For Ruari, and in memory of Antonia at Carsai

4

Contents

1
Barbara Hepworth:
A Life

Barbara Hepworth's life spanned the first three-quarters of the twentieth century, and her career as an artist reflects something of the artistic climate as it changed through those decades. For a rather brief period – her early woman-hood – she was based in London, a cultural centre, but the rest of her life was spent, geographically at least, at one remove. Her career reflects not only artis-tic movements, but also the wider cultural shifts which Britain was undergoing at the time. Hepworth was still a schoolgirl during the First World War, and came to maturity as an artist just before the Second. Her experience absorbed the brief moment of internationalism which Britain enjoyed between the two wars – a moment which intensified as the later 1930s saw the arrival in Britain of many artists and intellectuals from Germany and Central Europe – before the country turned in again on itself to deal with the war and its aftermath. By the late 1950s Hepworth, like many of her peers, began to look beyond Europe to the United States as a new source of energy and activity.

At the outbreak of the Second World War Hepworth was thirty-six years old; mature, poised as an artist, now secure in her style, approach and her context. One could say that the war came at the worst of times for her. Her life until then appears to have been one in which she had gradually moved towards the centre of artistic debate, teaching herself, and placing herself in positions in which she would learn. These had been years in which she, like many young people, can primarily be positioned in the group context, but it is notable how those groups became progressively more cosmopolitan. From the Royal College of Art – where she was associated with the table of artists from Leeds – to the British School of Rome, then to looser groupings of artists who were living in the same area of London and who were at similar stages in their careers, and finally to more rigorously defined exhibiting groups, first British and then European, which were based on a common subscription to contro-versial artistic positions.

These pre-war years were also the ones in which Hepworth met many of the people who were to matter most to her. Thus in the pre-war period we see Hepworth, in her twenties, living a very rich emotional life; within a period of ten years she married her first husband, John Skeaping, with whom she had a son, and met the man who – without sentimentality or excess – can be called the love of her life, Ben Nicholson, and with him had triplets. During this time Hepworth also met Herbert Read, the writer and critic, who was to remain a lifelong friend, and Naum Gabo, the artist, with whom she was close for a briefer, but intense period. She also encountered, more fleetingly, a range of people – Mondrian, Herbin, Hélion, Arp, Moholy-Nagy, Giacometti, Kandinsky, Domela – who all marked strong artistic positions and represented the conti-nental debate. And, before any of these, she had of course met Henry Moore,

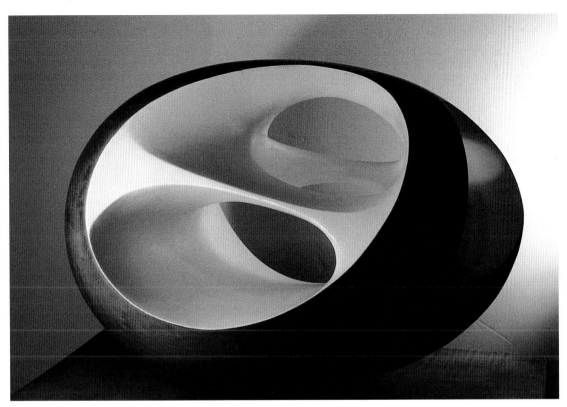

1
Oval Sculpture 1943
Part painted wood
L.41.9 cm

Pier Arts Centre, Stromness

with whom she remained closely associated from their art-school days up until the outbreak of the war.

The Second World War literally scattered most of these friends and colleagues, though at first Hepworth's group was reduced, rather than totally dispersed. She and Nicholson took refuge in St Ives, in the home of critic Adrian Stokes, where they were joined by Naum Gabo. However, one by one, even this tiny group separated. Gabo went to America, Stokes left in 1946 and Nicholson spent more and more time away. By the late 1940s Hepworth was totally alone, and was to remain so for the rest of her life, for the next twenty-five years.

Hepworth did not take life easily, but when she did enjoy it, it was with a great intensity. Despite her personal and professional sadnesses, and despite the fact that she lived through the Second World War, she succeeded in producing a body of work of great beauty. Hepworth's 'beauty' was clear and delineated, almost graphic. Her beauty represented poise and balance; anything clumsy or misjudged (in life as much as in art) was 'ugly'. She would not allow ugliness into her work, and this strength of thought lies behind everything she did. That she made herself find the good things is perhaps revealed by her words from just after the war:

Good things always seem concrete to me
Bad things seem amorphous

Barbara Hepworth was born in 1903 in Wakefield, just south of Leeds in Yorkshire, into a middle-class family, with whom she always kept in contact, and whose opinion she continued to respect. She appears to have been interested in form and movement from an early stage. She modelled her sister, who went on to become a professional ballerina, and herself took Dalcroze dance

classes. Hepworth always made great play, in her published statements, of the influence on her of the Yorkshire landscape, and of her experience of driving through it with her father, a County Surveyor.

Hepworth was always a high achiever, whose success within the process of formal education may have pushed her rather ahead of her own emotional maturity. At the age of just seventeen she began studying at the Leeds School of Art and moved to London, to study at the Royal College of Art, only a year later. She was at the Royal College in the early 1920s, a good time in its history, and one from which she must have benefited. William Rothenstein was the new Principal, anxious to turn it from being a teaching college dominated by young women and to expand it into a more prestigious establishment turning out the best practitioners in the fine arts.

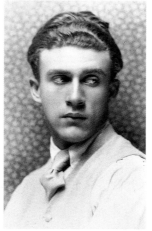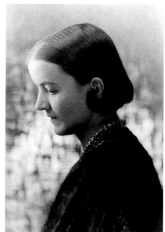

In 1923 Hepworth entered the Rome Scholarship competition, and though she got onto the final short-list she was pipped at the post by John Skeaping. Skeaping was making a name for himself as an unusually gifted artist, and though the scholarship competition was extremely traditional, demanding set-piece compositions for architectural reliefs, Skeaping won it with an approach less cautious and more individual than Hepworth's. Although within a few years Skeaping had fallen foul of an opposing faction of artists as represented by Moore, Hepworth and Nicholson, in the early 1920s his talent, and his exceptional experience of carving, won their admiration.

Though she did not win the Rome Scholarship, Hepworth won a travelling scholarship from her local council, and was thus able to join Skeaping in Italy. As it turned out, she did not even have to forego the experience of life at the British School in Rome, because she married Skeaping and was then able to take up residence with him there. That she was able to do this was thanks to the greater liberalism brought to the school by its new head, Bernard Ashmole, who was the first to allow wives to live with their husbands during their residencies.

Living with Skeaping in the British School probably benefited Hepworth most in terms of learning about carving. Skeaping was certainly well ahead of her in this because of his broader and more commercial experience. Though Hepworth had sought to find avenues into carving, she had been thwarted by the traditional syllabus at the Royal College. She had struggled – along with Moore – to find alternatives outside the college, whether in historical examples in the British Museum, or in the isolated examples of contemporary carving within the practice of British sculptors or, and even more rarely, continental exponents. Within the teaching syllabus carving was still seen as a craft subject, taught to those who saw their futures as architectural masons and designers. Skeaping had been even more precocious than Hepworth, and his early start at Goldsmiths' College meant he had been able to enjoy the vacuum in routine discipline occasioned by the war and which was perpetuated at the Central

2 and 3
Studio portraits of John Skeaping and Barbara Hepworth in the 1920s

4
Figure 1933
White alabaster
H.38.1 cm
Whereabouts unknown

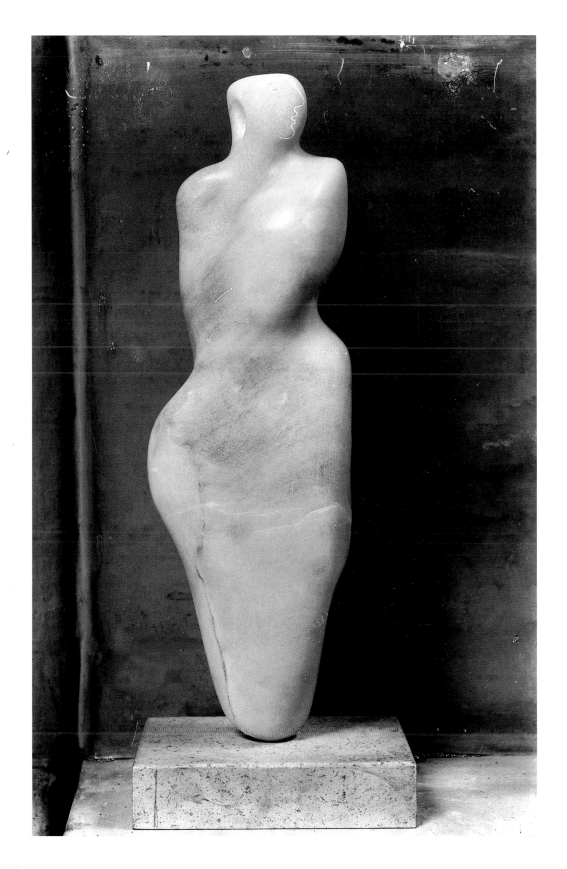

9

Schools and the Royal Academy, where he bene-
fited from the absence of the older students who
had been called up to serve with the armed forces.
In Italy, Skeaping had put his carving to the test by
working on cemetery sculpture for a monumental
mason, and at the British School Ashmole's inter-
est in identifying antique marbles, and their specif-
ic qualities, helped to propagate an environment
conducive to the practice of stone carving. Skeap-
ing's legacy to all those British artists who have
followed him to the British School in Rome is the
fountain, carved in shallow relief, which stands in
its courtyard.

When Hepworth and Skeaping returned to
London (prematurely, in fact, because Skeaping
had been ill), they found themselves modestly in
the limelight as a couple of talented carvers. They
were able to make a niche for themselves by build-
ing on some of the contacts they had made
through the British School, and in particular with a
circle of collectors and curators connected to Sir
George Hill of the British Museum, who had been
on the school's board, and to their supporter,
Richard Bedford, a curator at the Victoria and Albert Museum who was himself
a sculptor. These people, accustomed to semi-abstract objects – often carv-
ings of animals – from non-Western cultures, were able to appreciate the
stylised and simplifying approach which the Skeapings brought to their treat-
ment of natural forms. They too used animals and birds more than the human
figure, because these motifs lent themselves more readily to such abstraction.
The Skeapings were well received in press reviews of their joint exhibitions and
were placed among other respected carvers of the time, most of whom have
now been forgotten. Direct carving into the stone, rather than the convention of
modelling a clay original and then having that converted into bronze or stone,
had already taken hold in the English art world of the 1920s, and critics were
well disposed towards this new approach.

The later 1920s – following their return from Rome in 1926 – were marked by
the Skeapings establishing themselves in studios in North London, where they
exhibited both semi-privately and publicly, and by the birth of their son Paul in
1929. Their marriage, however, was nearly at its end, for in 1931 Hepworth spent
some time with Ben Nicholson, whom she and Skeaping had asked as their
guest on a Norfolk holiday which had been set up by Moore as a chance for the
Skeapings to patch up their marriage. Nicholson was a painter nearly ten years
Hepworth's senior. Although both were married, this neither stopped them from
entering into a passionate correspondence, nor from meeting again, nor from,
before long, living together whenever Ben was not in Paris with his wife,
Winifred. One way in which all three – Barbara, Ben and Winifred – were able
to deal with their complicated situation was by means of recourse to Christian
Science. Winifred is well known for her allegiance to Christian Science, but it
was also familiar to Hepworth, whose parents subscribed to its precepts.
Throughout her correspondence with Nicholson, Hepworth would often ask
him to hold the 'right thoughts' about whatever was troubling her.

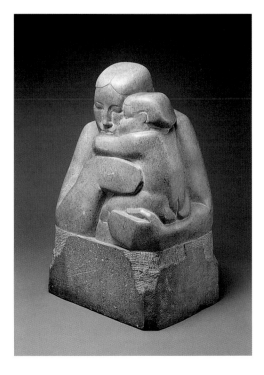

5
Mother and Child 1927
Hopton wood stone
H.38.1 cm
Art Gallery of Ontario

6
Ben Nicholson,
c.1942–8

7
Hepworth carving
Musician in c.1929
(see fig.51)

By October 1931 Hepworth and Skeaping had decided to divorce, and were not supposed to meet thereafter for a year, but by the following summer their relationship had become less strained, and they even went dancing at the Astoria and Hammersmith Palais and swimming together. Skeaping had 'never been nicer to her', and even changed his mind about divorcing. However, the divorce was scheduled, and 1933 opened with a certain amount of press coverage about the split which upset Hepworth and her parents. By the end of the year, the newly divorced Hepworth was looking for Nicholson to take a similar decision regarding his own marriage with Winifred, but she was not able finally to marry him until late in 1938.

It is interesting to note that Nicholson and Skeaping had much in common; both came from backgrounds rather more colourful and cosmopolitan than Hepworth's own, they brought greater experience of art – Skeaping perhaps primarily in technique, Nicholson rather in aesthetic context – and they were both great sportsmen.

It is clear from her letters that Hepworth relished both living in London in the 1930s and her relationship with Nicholson. These letters communicate a tremendous *joie de vivre*: in learning tennis, playing squash, promoting ping-pong, going dancing, or listening to Louis Armstrong. Nevertheless, the fun is always underlaid with a hint of seriousness, an earnestness which means that a game of tennis is not just a game, but also a marker of a way of being, a symbol for the precision and balance which both Nicholson and Hepworth sought to bestow on all aspects of their life. They had a great eye for the beautiful detail, for the charming aspect of a pencil, or for the spot of colour which would bring to life an otherwise dull corner in a room.

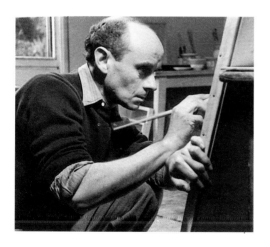

Some of this obsessive concern with the look of everyday objects was fed into, and fed by, their need for money. Both designed textiles, curtains and ceramics for retailers in the hope that success would alleviate some of the financial pressure. For a while Hepworth experimented with photograms and was encouraged by Marcus Brumwell, who ran an advertising company, to persevere with these as possible motifs for his business. Hepworth reluctantly took on a pupil, who turned out to be the charming daughter of the composer Arthur Bliss. The financial burden was only exacerbated when, in October 1934, Hepworth gave birth to triplets, though the problem of money was not then at the forefront of her mind. Strangely enough, we are able to read of Hepworth's feelings at the time in her letters to Nicholson, for he was still based in Paris. Though Hepworth never reproaches him for his absence, it is hard not to read some kind of anxiety into the words of a woman who has to tell her lover by letter that she has gone into labour, and 'please do what you think best about being here'. Hepworth's most vocal concern, however, was about 'being separated from carving by nurses undernurses and cooks', and by Christmas she was determined to start work again in the New Year. 'It is 5 months or more since I did any [work]. It has gone into those babies.' This was made possible by her friend Margaret Gardiner offering the £250 a year needed to send the children to Wellgarth Crèche, a nursery in Golders Green. Though Hepworth rehearsed the question of putting the children in Wellgarth, she came out with a clear answer: 'We shall be twice as much use to these babies if we are producing good work.' By January 1935 Hepworth was raring to go, 'so clear and so full of ideas'.

Alongside the struggle for money and time, as played out on the domestic front, there was the more occasional incursion of the art world. Hepworth would be reminded that she was now, if only modestly, a recognised ingredient within a certain context, and that her studio in Hampstead might be a port of call for visitors on the art circuit from abroad. While she welcomed the support of the occasional purchaser, it is these visits from foreign visitors which enable us to see how she was becoming a known commodity. She had made inroads into the continental network by accompanying Nicholson on some of his visits to artists working in France, and she endeavoured to keep in touch with them by means of letters and photographs of her new works. Every now and again there was the visit of a foreign collector, such as Hilla von Rebay (who was purchasing for what was ultimately to be the Guggenheim Museum in New York)

or the curator of the Hanover Museum, which proved that Hepworth was now on some people's lists.

Increasingly, the people who were important to Hepworth were from France rather than from Britain. She was anxious to hear from Nicholson what their artist friends were up to, and what they thought of her work. She met Picasso, Braque, Brancusi, Sophie Taeuber-Arp and Arp, and became particularly close to Mondrian, who came to live near her in London in 1938, and to Herbin and Hélion, who invited her to become a member of their *Abstraction-Création* group. She became involved in their efforts to clarify the 'true' direction of abstraction in contradistinction, as they saw it, to the way Surrealism was leading. The Swiss artist Hans Erni (who was to spend some time staying with Hepworth and Nicholson in London) made a determined attempt to clarify the field in his 1935 show, *Thesis, Synthesis, Antithesis* at the Kunstmuseum in Lucerne. It became more important, and part of the effort on both sides, to publish statements of intent, and though the 'pure' abstractionists never produced anything to rival the sustained literature of Surrealism, Hepworth was involved in the compilation of *Circle*, published in 1937, and took very seriously the writing of her own piece of text. Hepworth was always interested in writing, and while Adrian Stokes may have helped her to write, she also helped others, and was by no means reticent about picking up inconsistencies or misleading turns of phrase.

The war affected everyone, and artists in different and specific ways, partly depending on the point they had reached in 1939. Hepworth had by then succeeded in establishing herself in a second phase of her career, having rejected the first, more purely English phase, which had been premised on a carving which never separated the abstract from the figurative. In 1936 the International Surrealist Exhibition had been mounted in London, which had served to intensify activity and interest in the form of contemporary art a year before *Circle* was published. The war came at a real turning point for Hepworth, halfway through her life. She had been in the thick of the debate on abstraction and in the artistic life of the capital. She was clearly in her element. The war put an end to all this: the hive of activity, the flurries of communication and the

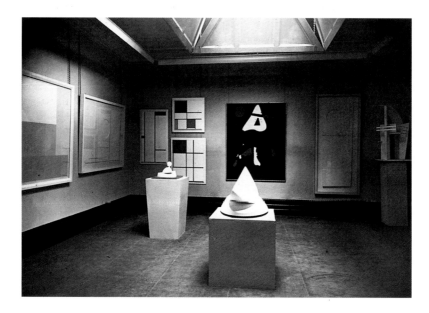

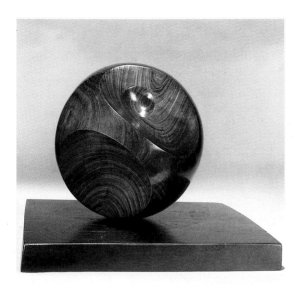

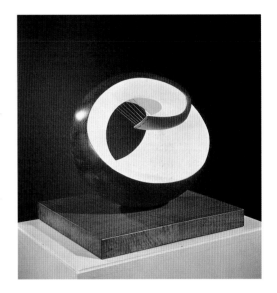

fluidity. Concerned for the safety of their work and reputations in wartime Britain, Hepworth and Nicholson compiled albums of photographs of their output up to 1940, which they put into the safekeeping of an American painter friend, who succeeded in selling them to the Museum of Modern Art on their behalf. Though the worst did not come to pass, Hepworth did lose a number of works to wartime damage.

After the war things did not take up where they had left off, and Hepworth, to her own surprise, never returned to London, or indeed to any other metropolitan centre. Her colleagues were also scattered: Moore to Hertfordshire, where he remained all his life; Read to Yorkshire; Mondrian, and later Gabo, to America. Perhaps the truest fruits of Hepworth's experiences of the 1930s are those uniquely individual wood carvings which she was able to start making towards the end of the war (for example, fig.12), and which comprise an eloquent but brief swan-song to that period of her work.

The outbreak of war caught the Hepworth-Nicholson family somewhat by surprise on their holiday in St Ives; their retreat there was never premeditated. However, after their stay with Adrian Stokes and his new wife Margaret Mellis, they moved on to find their own house in Carbis Bay, adjacent to St Ives itself. Gabo and his wife were also to follow the Stokes's suggestion of taking refuge in Carbis Bay. Not until 1942 did Hepworth have a studio where she could make sculpture again, and in any case she was also busy during the war running a nursery school and a market garden. She was worried about her children who, by the account of her letters, seemed to be ill all too often, as she was herself – and about providing them with a healthy diet. Things became more serious when one of her daughters developed osteomyelitis, which naturally worried Hepworth as a mother, but also pained her, aesthetically, as an artist.

At the end of the war the children went off to Dartington Hall, a progressive boarding school in Devon, their fees taken care of by scholarships. However, her time spent with children, and in particular watching them draw and model with Plasticine, does seem to have deepened Hepworth's own developing interest in the unconscious nature of making, and of the magic or secret life of forms. This, combined with the power of the Cornish natural and man-made landscape, can surely be seen as drawing her away from the logical

life of the mind and into some of the deeper, inarticulate recesses already entered into by Surrealism.

Aside from these rather private influences, Hepworth was not only influenced inevitably by the war, but was also, perhaps less predictably, enthused by the mood of reconstruction in which, somewhat surprisingly, the British Government now offered the artist a role. On reflection, it is perhaps not so surprising that an artist involved with the objective abstraction of the 1930s, which had some roots in Soviet Constructivism, which had always aimed to be politically based (in that it was an art for a new kind of society, anti-Victorian, anti-bourgeois), and which had begun, if only in a small way, to bring good design into everyday life, should be pleased to be given a chance to put that interest into practice.

During the early years in St Ives Hepworth was close to Naum Gabo, with whom she shared some of her developing ideas. This may have been a measure of her estrangement from Nicholson, but was also a sign of Hepworth's and Gabo's joint interest in assessing whether what they had understood as Constructivism was coming into being in its fullest sense. In some ways the war might be seen as a time during which they regrouped and re-armed. The magazine *World Review* promoted their cause, and its art editor, Marcus Brumwell, also edited a series called *This Changing World*, which involved many of their circle.

The new situation demanded changes. This was not simply the chance to make on a larger scale the art they had made in the 1930s. As Hepworth said to Nicholson: 'It is hopeless to presume that I, or anybody, thinks the same as in 1936, either about Art, Philosophy or Religion. You won't have a friend who thinks the same after this war as they did before it.' The experience of the Holocaust (Hepworth purposefully went to the cinema to see reportage from Belsen) altered the perception of the human body, and of the individual's role within society, and brought Hepworth to a more rounded approach which she defined as religious. Hepworth was always very anxious about her own and her family's health, and what may seem like hypochondria can be explained by her sense of form, which brought physical wholeness and the beautiful idea into a kind of symbiosis. Hepworth's response to good sound – the regular rhythm of successful carving – as opposed to bad sound – the ugly interruption, be it human or technical – depends on a similar world view. As ever, Hepworth's response to the madness and disease in the world was to want to make 'as many good sculptures as one can before one dies'. This is why Hepworth's wooden sculptures were a brief but finite series which represent the fusion of artist and landscape in seclusion from a wider world. By the time the Second World War had really entered Hepworth's consciousness, and she was apprised of the new role that was being offered her, she turned to the human figure, to the monolith, to a public rather than a private sculpture.

Hepworth's move towards anthropomorphism and her perhaps naive embrace of 'public art' may be symptoms of the space that was opening up between her and Nicholson, who was increasingly absent from St Ives, leaving Hepworth to provide a family base in far from ideal conditions. The restoration of peace in Europe did not restore stability to the Hepworth-Nicholson family. Their letters became bad-tempered and, on Hepworth's side, rather despairing. Nicholson was a hard taskmaster, and Hepworth found herself in the position of never being able to please him. She was either found wanting, or accused of trying too hard and of being too anxious to please. In 1951 they were divorced.

13
Biolith 1948–9
Blue limestone
H.152.4 cm
Jonathan Clark

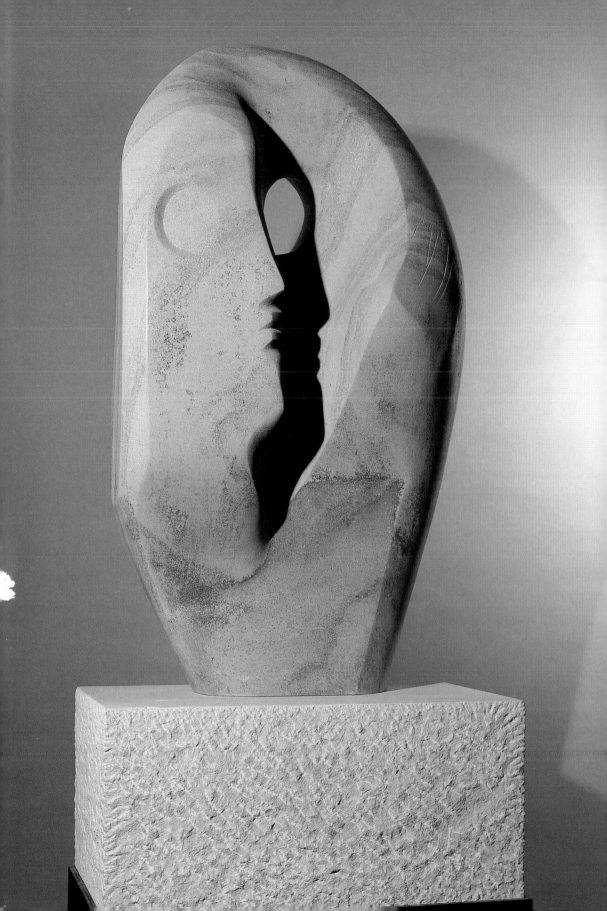

The years following the war – the later 1940s and the early 1950s – are perhaps those when Hepworth was most miserable, despite her growing public success.

Their break effectively came at the time that Hepworth bought Trewyn Studio in the heart of St Ives, a space which she now needed in order to execute her first large commission, an eight feet high carving for the 1951 Festival of Britain. From 1949 this was her base, and this commission really marks the beginning of a new stage in her career, in which Hepworth struck out as an independent artist, receiving public commissions and the status they brought with them. Hepworth was not the only one in St Ives involved with the Festival; Nicholson also had a commission, as did Lanyon, Heron and Wynter.

I have suggested that some of Hepworth's enthusiasm for public sculpture in the 1950s relates to her 1930s' affiliations, particularly the role that democratic art had in that group's thinking. An awareness of the 1930s, and of how important they were, both in themselves, and as a prefiguration of what was to come, is increasingly evident in Hepworth's thinking. This made it important for her to secure her own position within that movement, so that as an individual artist she was considered alongside Moore, Gabo, Nicholson and others. This, however, left her, and us, in a rather contradictory position. In one way she read the 1950s political engagement in art as being actual, current, and consistent with her own pre-war hopes. In another way, she located the real moment of artistic truth as one that had happened twenty years previously, and wanted herself to be placed at the heart of that historic moment rather than anywhere else. Through the 1950s Hepworth tried to juggle these two emerging and contradictory positions; by the 1960s she had plumped definitively for the 1930s, and for her position within that pioneering generation.

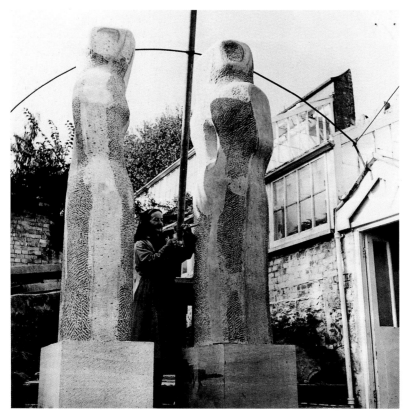

14
Hepworth carving
Contrapuntal Forms in
1950

15
Contrapuntal Forms
1951
Blue limestone
H.304.8 cm

Harlow New Town, Essex

The new artistic bodies which emerged from the war – the Arts Council and the British Council – as well as the opportunities offered sculptors by the Festival of Britain, London County Council and other local councils and education authorities, gave many new kinds of work to artists, and especially to sculptors. The new climate made a particular difference to St Ives; the Arts Council was concerned to decentralise funding, and studios and galleries received subsidies which helped them to organise more professionally. One such beneficiary was the Penwith Society of Arts, set up in 1949 by the 'modern' artists in the St Ives Society as a secession group, with Herbert Read as their president. It was one of the first organisations outside the capital to receive Arts Council funds.

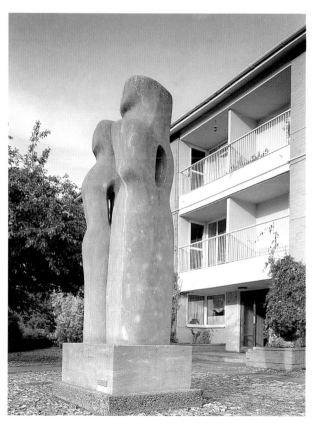

For a brief time, the avant-garde and the establishment came together, and sculptors who had perceived themselves to be 'outside' society were now being offered opportunities to place art within the community by government funded agencies.

In 1950 Hepworth was the British Council's choice to follow Henry Moore as their representative in the British pavilion at the Venice Biennale, and her poor reception there may well have set Hepworth thinking about the way their two careers were turning out, and how she, despite considerable success, was trailing well behind Moore in all kinds of ways. (Despite their private estrangement, Nicholson seems to have remained Hepworth's supporter in public places, and used his own position as a senior British artist whose work was toured overseas by the British Council to question why she was not getting the promotion that she deserved.) Moore was very much the British Council's ambassador, and he was the choice of most of the foreign countries who wanted the Council to support exhibitions in their countries. Moore was toured more, exhibited more, commissioned more, and sold at higher prices. Moore sat on more committees and juries than Hepworth, and played a greater part in public life. His personality seemed to be perfectly suited to advancing the cause of British modern art to both the 'man in the street' and to the foreign sceptic. Hepworth's personality was much less well suited, and she often came across as shy or anxious. Much of Hepworth's energy in the 1950s was therefore spent urging her gallery to push her work more proactively (she eventually changed Gimpels, her long-time supporters, in favour of the Marlborough Gallery), and considering how to place herself so as to appear to greater advantage.

Nevertheless, despite her worries, public recognition arrived. In 1952 a major monograph on Hepworth's work was published, with a preface by Herbert Read, but with the most significant groupings and statements being made by

19

the artist herself. This continued and established the tradition whereby Hepworth has been mainly described in her own words. Alongside the public commissions, she had two retrospective exhibitions at the Whitechapel Gallery in London in 1954 and in 1962, was the British Council's representative at the Sao Paolo Biennial in 1959 (where she won the major award) and began to receive a number of official accolades and honours, as well as responsibilities, such as being made a trustee of the Tate Gallery in 1965.

All this was carried out, in relative physical isolation, from Trewyn Studio in St Ives, which became accustomed to the complicated business of getting large-scale sculptures ferried out from its narrow winding streets. In her *Pictorial Autobiography* Hepworth said: 'I am so fortunate here to have a garden and space and buildings where I can make such a mess and be tolerated. And so one isn't an oddity, but just another chap rushing out in overalls to buy some more files at the nearest shop. St Ives has absolutely enraptured me, not merely for its beauty, but the naturalness of life ... the sense of community is, I think, a very important factor in an artist's life.' Gradually Hepworth's home base became more peopled, with a small group of assistants, including a secretary. Nevertheless, she was essentially a single woman who had additionally to look after her children when they were at home. Though St Ives was far from London, and Hepworth liked to keep to a minimum her journeys up there (where she had a suite at the Great Western Royal Hotel beside Paddington station), she was by no means isolated from the wider world of exhibiting. She had a small storeroom in Ladbroke Grove, on loan from her friend and helpmeet, the composer Priaulx Rainier. Her mind was always running on what to show, where and when. Her single-minded devotion to work was rarely broken, and when she did have to look after her children, she worked into the night to recoup lost hours. She kept in contact with friends – particularly Read – by correspondence, and in the summer old friends, like Norman Reid or Anthony Lousada, made the journey down to visit her in Cornwall. But emotionally Hepworth seems mostly to have been alone at this time, still in a kind of grieving for Nicholson.

One might identify Hepworth's friendship with Dag Hammarskjöld as almost unique in breaking into this emotional isolation. Hepworth only knew the Secretary General of the United Nations for five years before his premature death in 1961, and though their relationship was mainly carried out by letter, it was clearly of unusual significance for both, and helps towards an understanding of Hepworth's character. Hammarskjöld's spiritual asceticism and devotion to the cause of the United Nations inspired Hepworth who was, anyway, of a generation to view the UN as an effective cause for good. Hepworth was left wing, in

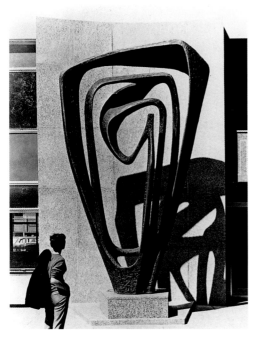

16
Meridian 1958–9, installed outside State House, Holborn, London
Bronze H.457 cm
Pepsico Corporation, USA

17
A view from the carving studio in Trewyn

theory if not in practice, and had got somewhat involved in supporting campaigns for the Soviet Union and for CND. Hammarskjöld described how he found his explanation of 'how man should live a life of active social service in full harmony with himself as a member of the community of the spirit in the writings of those great medieval mystics', and his words are not far from Hepworth's sense of her own mission. Her sculptures certainly found an echo in Hammarskjöld, who kept one on his desk, and who appreciated their combination of movement and stasis. Hepworth gave him a number of pieces, he visited her exhibitions, and before his death he had even talked of commissioning her to make a piece for the grounds of the UN headquarters in New York. When his plane was shot down over the Congo in August 1961, this commission was translated into a memorial, and Hepworth's *Single Form* (fig.19) was erected, twenty-two feet high, outside the Secretariat, in 1964. In the papers found by Hammarskjöld's bedside after his death, and published posthumously as *Markings* (translated by W.H. Auden), there is a short poem entitled *Single Form*:

The breaking wave
And the muscle as it contracts
Obey the same law.
An austere line
Gathers the body's play of strength
In a bold balance.
Shall my soul meet
This curve, as a bend in the road
On her way to form?

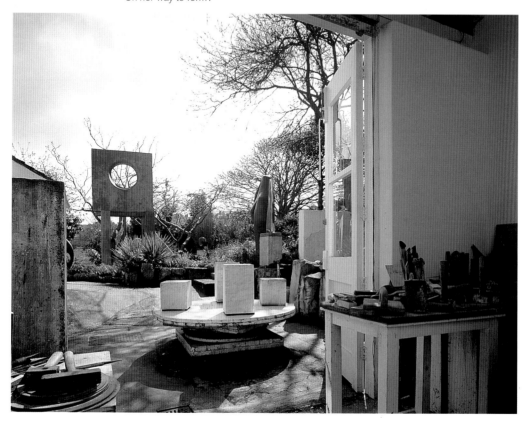

After Hepworth read the proofs, she told Read: 'Very strange – it all fitted my letters.'

When, in 1965, Hepworth was elected a trustee of the Tate, she did not know that her visits there were to become associated with her fight against cancer. When she went to the Tate, she also visited her specialist at the nearby Westminster Hospital. The last ten years of her life were thus spent under the shadow of cancer, fighting back resolutely, but always losing ground. As early as 1965, when she was delighted by the way her work looked at the Kröller-Müller Museum in Holland, and excited about other opportunities, she told Herbert Read that she had asked her 'doctor to keep her alive for 3 or 4 months!' Another unexpected coincidence was that these years would bring her back into contact with her dear friend, for Read was not only a fellow Trustee, but also a cancer sufferer who was to die in 1968. Their correspondence at this time reveals the poignant comparisons made by two contemporaries who have suddenly grown old together, and who realise they never gave themselves enough time to enjoy their friendship, because they had both worked so hard. Read was also able to give her news of Nicholson and of her son Simon, from whom she was also estranged.

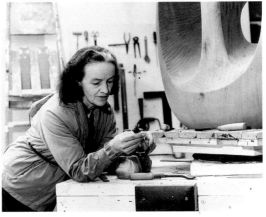

In 1973 Hepworth's seventieth birthday was celebrated at the Tregenna Castle Hotel in St Ives. The party was organised by Harry Fischer from the Marlborough Gallery, and many guests came down from London for the occasion. Her last years were spent in great pain, but Hepworth never gave up, either in making her work or in planning for the future. Thus her sudden death in an accidental fire at Trewyn Studio one night in the early summer of 1975 came as no less of a shock to everyone. She had been working with her assistants to ensure a steady production, which was dominated by small scale carvings, but which also included a handful of important large scale projects, specifically designed for physical interaction. Despite the increasing introspection in her work, Hepworth was actively involved with her new gallery, Marlborough, and their promotion of her work abroad. She continued to receive honorary degrees, and films were made about her work, but one of her most significant achievements was the *Pictorial Autobiography* which was published in 1970. The art historian Alan Bowness had become one of her two sons-in-law in 1957, and he began to order her papers and organise their presentation. It was his initiative to put together the *Autobiography*, though its mixed genesis has since caused confusion in attributing to Hepworth the wish to have the last word.

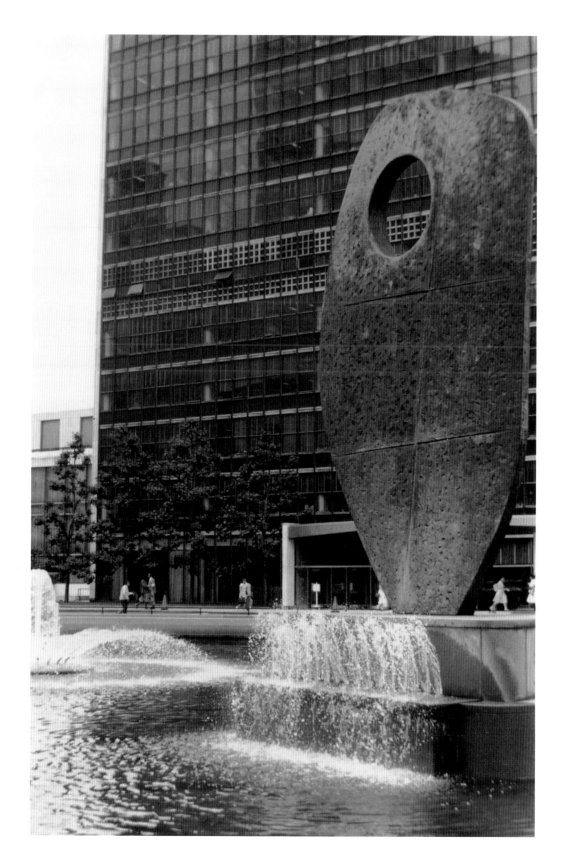

2
The Work

Barbara Hepworth worked for fifty years, from 1925 to 1975, and made nearly six hundred works. Her output is unusually focused on sculpture itself. Though she made some drawings, paintings and lithographs, these are occasional within her work as a whole, and her oeuvre does not contain the diversity of media employed by many sculptors, and notably, Henry Moore. Her sculpture is often thought of as being not so much consistent, or typical, as stereotypical. Just as we all 'know what we mean' when we think of a Moore, so it may seem easy to think we know what we mean by a Hepworth. Yet, when we look through all the works she made, it is surprisingly hard to find that 'typical' piece.

Though a closer look at either artist's career quickly complicates this simplistic view, Hepworth's work is decidedly more varied than Moore's. In fact, it becomes all too easy to divide her career up into neat little parcels, and to forget the consistency that runs throughout. So the aim of this chapter is to keep the two threads running together, to differentiate one period from another, while establishing the relationship of each to the artist's principal concerns. It is useful to attempt this kind of thing in a book, because her works are so scattered, and we rarely see many together. Therefore, and because her later work in particular is neglected, I have consciously made a point of trying to describe what is happening from the evidence of the work itself.

At its simplest, Hepworth's work might be divided into three distinct stages defined by the material in which she makes the most innovative pieces at that time: first stone, then wood, and finally bronze. The first period lasted until the outbreak of war, the second through the 1940s up to 1956, the third from then on, through the 1960s. The shifts in material are in accord with her overall aim – which could be defined as opening up the form to allow the viewer's involvement – and come about in order to facilitate this process and take it a step further.

Early work is usually the most difficult to pin down, partly because artists tend to disown student pieces and to destroy them, or to omit them from the catalogues. They also forget them. In Hepworth's case it is hard to work out how many of the omissions from the 1961 catalogue of her work (see bibliography), which she helped to establish, are deliberate, and how many accidental. In her own archives Hepworth kept records of a few works she made while a student; some were modelled in clay or plaster, and two portrait heads were cast in bronze. She began to carve some time in the mid-1920s, and our earliest record of a carved piece is a dove which may date back to her time in Italy with Skeaping.

Much of the work done by English sculptors in the 1920s brought animal subjects and direct carving together, as a route into abstraction through the material. Artists were keen to link their idea for a subject to the suitability of the

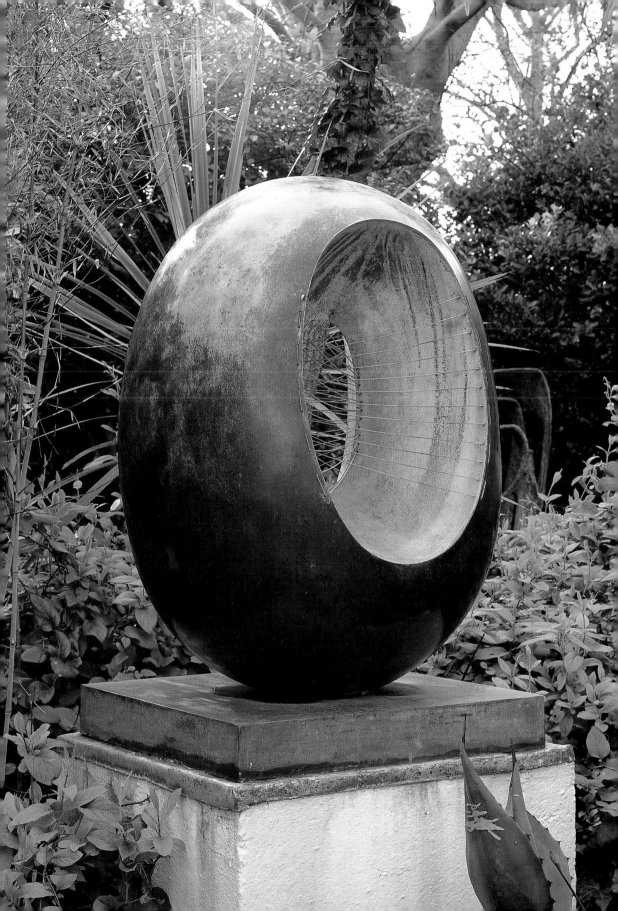

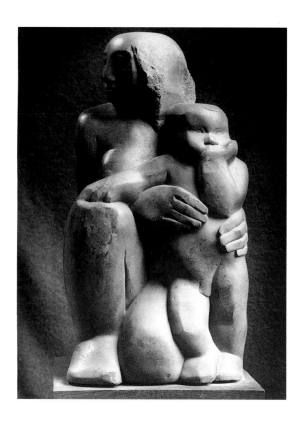

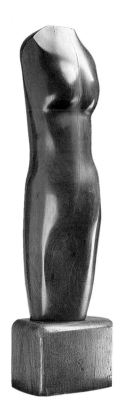

material, rather than modelling anything and everything in clay, and only think-ing about a final material thereafter. Stone was now allowed to suggest or inspire the subject, so that the artist worked in tandem with his or her material. Thus the work was started and finished by the person who had conceived it, rather than it being passed on to professional carvers or bronze casters. One side-effect of this new interest in direct carving, however, was that finished sculptures became much smaller. In the absence of the production line, artists had neither the skills, nor the time, nor the inclination, to carve large areas of stone. Carvings now became private in scale and in form, for the desk, mantel-piece or pocket, rather than for the entrance hall. There was a conscious reaction away from Italian marbles (and Italian marble-carvers) towards English stones, or at least to a much wider range of stones than had been traditional up to that time.

Hepworth began using Carrara marble, but soon moved on to English Hopton wood stone (a great favourite of the time), Irish fossil marble, Cornish serpentine, alabaster, and Ancaster stone. Using unusual stones and demon-strating prowess in tackling very hard materials became quite a specialism, which diverted a number of artists including, arguably, John Skeaping. Animal and bird subjects seemed to provide those artists who were nervous of ab-straction, and just finding their feet within its vocabulary, with the necessary mix of guiding inspiration and freedom. Moreover, animal forms were particularly suitable to a material which came in compact blocks.

Hepworth's first carvings were of doves, and in the 1920s she made at least five birds, a frog and a dog. However, she was not long in putting some dis-tance between herself and the fashion for animal sculpture, and, aside from a couple of bronze busts, the rest of her sculptures from this time are carvings of

21
Mother and Child 1929
Brown Hornton stone
L.35.6 cm
Whereabouts unknown

22
Torso 1929
African ivory wood
H.31.8 cm
Whitworth Art Gallery,
Manchester

23
Kneeling Figure 1932
Rosewood H.68.6 cm
Wakefield City Art Gallery

the human figure. Up until 1929 all these carvings were in stone. Stone encourages compact or squat forms, rather than the vertical possibilities of wood. Thus, among Hepworth's early figures, we find a seated figure, a reclining figure, torsos (for example, fig.22), a figure with folded arms, a musician, a flute-player, a group of masks, and two mother and child groups (figs.5 and 21), the last from 1929, the year in which Hepworth bore her first child. Stone both forces and encourages the deployment of folded, encircling, wrapping arms which lead into the circularity and openness of her later work.

Many sculptors at this time were strongly influenced by the methods they found for dealing with stone and wood in the antiquities and ethnographic galleries of museums. Though Hepworth was interested, her work does not show such strong influences as that of others. The masks she made might suggest the antique in general, but not the specific Mexican influences so clearly visible in Henry Moore at the same time. The clearest parallel between her work and the museum is in *Musician* of 1929 (fig.51), whose form and material, a golden alabaster, is unavoidably Cycladic.

In 1929 Hepworth began to use wood, and with it made both some rather long and elegant figures – with and without their heads, the latter approaching pure form – and their very opposite, a chunky and lifelike *Infant.* These carvings are in African hardwoods, and have a considerable degree of polish, which is an active ingredient in uniting the planes and in drawing in the play of light. Although their length and girth were determined by the wood's origins in the tree-trunk, the shine helps the eye to forget the block, and to see the form as being freer in space.

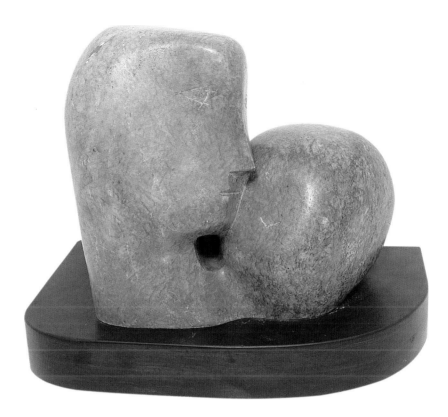

24
Figure of a Woman
1929–30
Corsehill stone
H.53.3 cm
Tate Gallery

25
Figure in Sycamore
1931
Sycamore H.63.5 cm
Pier Arts Centre, Stromness

26
Two Heads 1932
Cumberland alabaster
L.38.1 cm
Pier Arts Centre, Stromness

Around thirty sculptures by Hepworth are known of from 1925 up to the end of the decade. The works from 1930 itself should in fact be added to these, as they make a group with the works of the 1920s. (Some indeed, and especially the animal subjects, can seem positively backward-looking.) *Carving*, which represents a half-figure with crossed hands, and *Head* both show a harshness in their outlines and their frontality which has little in common with the much more undulating profiles which began to emerge in the 1930s. Despite its monumentality, and the almost ponderous treatment of the hands, the Tate's *Figure of a Woman* (fig.24) does intimate the greater and more rounded three-dimensionality that was to come.

In 1932 Hepworth concluded her more monumental treatment of an almost Amazonian female figure with two remarkable pieces in wood, each around two feet high, *Kneeling Figure* (fig.23) and *Mother and Child*. Though the latter is lost, the former survives in Wakefield City Art Gallery. They both have a lively alertness which is unusual in Hepworth's more quiescent figures, and is more akin to Moore. Their connections with African carving suggest that another, much simpler piece, the *Torso* in Aberdeen Art Gallery, might also be brought into this fold.

Otherwise the 1930s heralded a new ambiguity, a flickering profile, in which drawing was superimposed on form. This tendency is introduced in a piece which Margaret Gardiner bought from her friend, and which is now in her collection in the Pier Arts Centre, Stromness: *Figure in Sycamore* of 1931 (fig.25). This work never sits still, demands that you walk around it, and is unphotographable. Its movement is steady, rather than abrupt. Despite its success in formal terms, this figure has a quiet modesty. Might one argue that this is a woman as perceived by a woman? There is the ripple of hard and soft, the

29

elision of bone and flesh, that is known from one's own sense of touch. At any rate it seems to be right, to belong, in a manner that is absolute but also unassuming. It has a close cousin in *Figure* of 1933 (fig.4), which the Bliss family bought from the artist who was also teaching their daughter.

The works of the first half of the 1930s are still figurative, but their softness allows them also to live a life as form in itself. *Two Heads* (fig.26) shows very

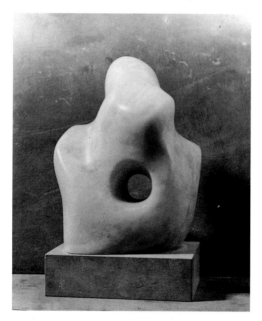

clearly the fertile ground allowed to figurative works when abstraction is embraced in a manner that is both bolder and less self-conscious. These two heads come together but stay apart, they are defined and undefined, there is definition in the graphic marks that denote the eyes, but the forms and their profiles slip and wriggle free of the analytic eye. They evoke the forms created by the erosion of the sea – and of the wind – which Hepworth picked up on the Norfolk coast at Happisburgh.

In 1933 Hepworth exhibited an *Abstraction* at the '7 and 5' group exhibition, which Read later illustrated as *Carving*, and which we now have in the 1961 catalogue of Hepworth sculpture as *Pierced Form* (fig.27). This work was destroyed in the war, and the next pierced sculptures, *Profile* of 1932 (now lost) and *Figure* of 1933, make much less of the hole and belong more properly to the softly undulating and linear works described above. This group continued in a series of upright figures in which the head tops a truncated body, which is either seated or terminates by means of folded arms (see *Sculpture with Profiles*, fig.28, and *Seated Figure*, both of 1932 and in the Tate Gallery).

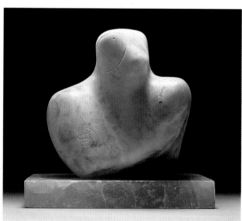

27
Pierced Form 1931
Pink alabaster
H.25.4 cm
Destroyed in the Second World War

28
Sculpture with Profiles 1932
Alabaster H.23 cm
Tate Gallery

29
Mother and Child 1934
Pink Ancaster stone
H.30.5 cm
Wakefield City Art Gallery

It was also in 1933 that Hepworth made a *Mother and Child* in which the pair contemplate each other, as if in an embrace. This was bought by her friend Douglas Jenkins, who had accompanied Hepworth on that fateful holiday in Norfolk where Hepworth fell in love with Nicholson. It is a bolder version of a composition which Hepworth had essayed the previous year, and neither of these has been seen on public display for a long time. However, they presage something more interesting (which can be seen in public), for in 1934 Hepworth took a significant step forward by making the baby a separate entity. This little form, in pink ancaster stone, now stands on its mother's lap in the Wakefield City Art Gallery (fig.29).

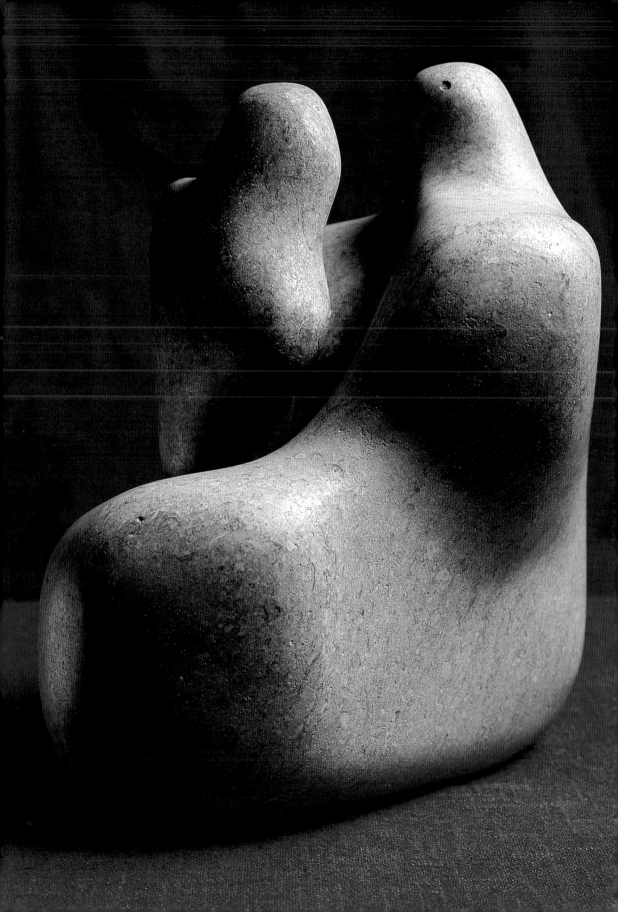

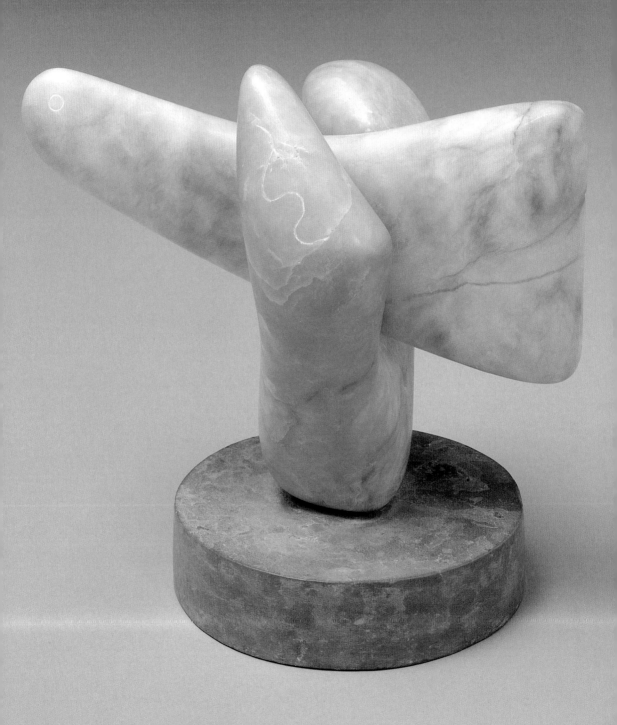

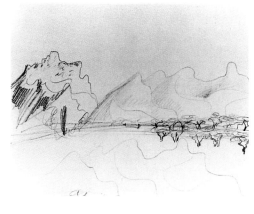

Hepworth was moving inexorably towards soft and thick profiles, echoing not only the erosion of small stones on the beach, but also the hills and mountain ranges across the landscape as a whole. The drawings she made in St Rémy in the south of France in 1933 (see fig.31) bring these links home; the mountains rise above the plain in a manner very close to the way she manipulated her own carvings in 1933–4. At this stage the memory of her visit to Arp's studio was fresh in Hepworth's mind: 'as we travelled on the train to Avignon … I stood in the corridor almost all the way looking out on the superb Rhone valley and thinking of the way Arp had fused landscape with the human form in so extraordinary a manner.'

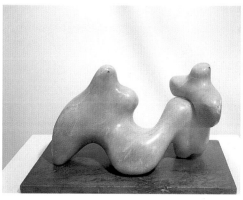

Hepworth made five figurative carvings which echo the mountain range, but all but one of them go even further, for they introduce the smaller, secondary form, which sits beside or on them, thus turning the Wakefield group on to its side. These are the works which inspired Adrian Stokes to test his own theories of carving, for Hepworth's work revealed the obsessive caressing of the surface which he understood as true carving, but she came out with fully three-dimensional results. Nevertheless, we can feed off the parallels between the sculptor as mother and the stone as mother. These works certainly complicate the rather tiresome notion of the stone engendering the form for the direct carver; here there is a tiering of this notion of genesis, which allows both literal and allegorical readings of giving birth. Certainly Hepworth's stone was no longer simply pierced, for its hole can now be read as what makes it complete. The introduction of a separate piece takes unique shape in *Two Forms* (fig.30) in which the relationship is no longer simply maternal, but active in a penetrative way which might be read as representing the sexual caress or sexual frustration.

Despite, or because of, Hepworth's second pregnancy, 1934 was a year of many changes. Although she was not able to work from the autumn through to the early winter of 1935, she made a lot of work before the babies' arrival, and it was quite different to what had gone before. But prior to the more sustained work she did on the multi-part composition, she introduced a form – the upright single form – which was to reappear in such strength in 1937, with a further six versions. The next work she made – *Two Forms with Sphere* – began a series which still used loose parts, but which reformed them into more regular shapes and laid them out on boards of similar materials. Alabaster, the dominant material of the mid-1930s, continued to be used for these pieces. The series might be counted as numbering around ten to a dozen, with either two or three forms

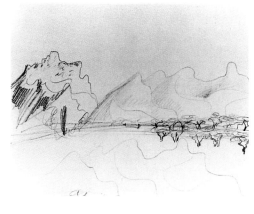
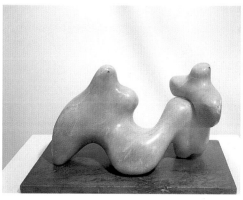

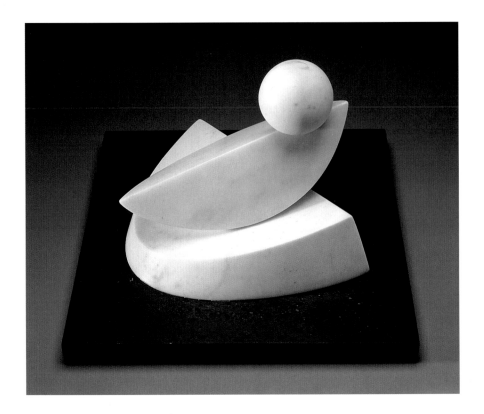

arranged on each platform. The first three were the most geometric, and after that the forms became both more rounded and more irregular, though they never returned to anything like the rugosity of the reclining figures.

In 1935 Hepworth made two works which are less about dispersion and more about physical relationship: *Two Segments* (which Hilla von Rebay bought) and *Two Segments and Sphere* (fig.33). The more active nature, and the potential involvement of the spectator with the work, was carried through in the continuation of the 'board games' in 1936 and 1937, in which hollows, concave circles and grooves invited the spectator to play. This variation in surface levels, making protruding bridges and lips alongside pierced holes and secondary planes, was developed in a group of half a dozen or so of Hepworth's most unusual — and most unknown — works between 1936 and 1938. They might be related most usefully to the dialogue she and Nicholson were having between themselves about painting and carving, and with their friends in France, who were mostly painters, about the nature of abstract language (see *Sculpture* and *Two Forms*, figs.34–5). These works again make reference to Stokes's theory of carving, which was played out much more on the picture surface, and especially in the work of Nicholson, than within sculpture itself.

Just before the war broke out it would appear that Hepworth was developing something new which she was not able to take up again until near the war's end. In 1938 she made *Helicoids in Sphere* (fig.11) which combined the notional integrity of a whole sphere with sections which are scooped out and opened up. This effective creation of an imaginary whole, a transparent exterior which gives on to an interior, is what made works like *Oval Sculpture* (fig.1), *Wave* (1943) and *Pelagos* (fig.12) famous, and was made possible by their being carved in wood. These works can, with reason, be seen as wedding Hepworth's

33
Two Segments and Sphere 1935–6
White marble 30.5 cm
Private Collection

34
Sculpture 1938
White marble
H.39.4 cm
Whereabouts unknown

35
Two Forms 1938
Honduras mahogany
H.38.1 cm
Private Collection

pre-war abstraction to her new location on the Penwith Peninsula, a kind of consummation of that relationship. This toe of land combines striking contrasts within a small area; tropical plants and bare moors, holiday villages and sublime beaches. The many bays and inlets, the encircling, incoming tides, the contrast in textures, might be seen to find their way into these particular pieces. The different man-made monuments – megaliths, tin-mine chimneys, or the conical heaps of china-clay – punctuate the natural landscape and find their echo in Hepworth's wider vocabulary. They too present clean clear lines rising above the dense horizontality of the aged landscape around them.

It was only during the war that Hepworth started to give her works names, rather than purely descriptive titles. Naming betokens a new spirit which one might attribute to Cornwall, and her new interest in the power of image and place, though it was in fact her confidante and critic in London, the writer E.H. Ramsden, who advised her on the more arcane or classical names, such as Eidos or Pelagos. During the war Hepworth was most grateful for Ramsden's insight and for her reviews, in which she was able to convey the quality of the new carvings, which she described as 'purposive', as 'inducing repose and generating a movement'. Perhaps we might discern in Hepworth a willingness to embrace both sides of this debate – both the organic and the constructive – which links her work at this time with contemporary continental efforts to effect such a synthesis. Whereas another artistic couple, Sophie Taeuber and Hans Arp, sought to manifest in their collaborations a deliberate marriage of the 'geometric' and the 'ageometric', Hepworth and Nicholson seemed to be forced into rather more polarised positions. Hepworth's synthesis involved a demonstration of the 'space-time' concepts then being developed in architecture, by fusing the exteriors of her sculptures with their interiors.

Whilst the war continued Hepworth was at first only able to make small plaster sculptures. Perhaps it was due to frustration, or the nearness of her focus, but these plaster works saw the introduction of two aspects which were to assume greater importance when added to her work in wood: interior colouring and stringing. Many of the works made just before and just after the end of the war used colour in their interiors, an innovative device which is entirely successful in bringing these works to their conclusion. Simply by applying a layer

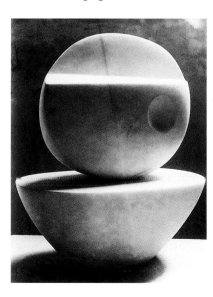
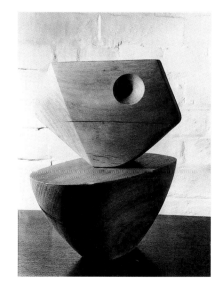

of paint to the 'inside' of the wood Hepworth succeeds in making us think of this interior as qualitatively different, as something necessarily internal. Hepworth's thinking about colour may have been influenced by her relationship with Mondrian, and its association with spiritualism and theosophy, as well as by her closeness to the pictorial debate.

The *Sculptures with Colour (Deep Blue and Red)* of 1940 led Hepworth in two directions. One was into the stringed and coloured pieces *Wave*, *Hollow Form* and *Pelagos*. The other was an even richer vein. The ovoid forms developed into a looping, double helix rather like the famous Möbius loop, which fed a wonderful series of nearly twenty pieces between 1944 and 1948. These are not well known, being mostly in private collections, but examples are *Bird (Hand sculpture)* (1945) in Israel, *Pendour* (1947) in the Hirshorn, *Helikon* (1948) in the Museum of Modern Art, New York, and the damaged version of *Tides* in the Tate. Hepworth's hand sculptures echo the training exercises of the Bauhaus school, where every student had to make sculptures by and for the hand. Such exercises also introduce that elusive element, the fourth dimension – or time – which was a factor in much contemporary debate.

This series of spirals was abruptly ended in 1948 by *Dancing Figure* and by the works which followed it – *Eocene*, *Biolith* (fig.13) and *Janus* – which rather uncomfortably impose the human profile into an 'abstract' form. These are probably the works which both Ben Nicholson and E. H. Ramsden found so difficult to welcome. One of these, *Perianth*, from 1948–52, has actually had its head

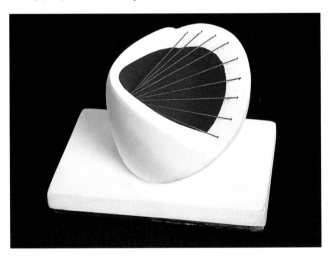

severed from its body, apparently under the influence of Nicholson's dislike of this figuration. Hepworth made a very explicit, and more resolved (if more conventional) return to the figurative when she made a memorial *Madonna and Child* for her son Paul, whose RAF plane crashed in 1953. The singular nature of this work is a rare demonstration of an explicit relationship between Hepworth's life and her work. Hitherto it was only with *The Cosdon Head* of 1949 that Hepworth succeeded in finding a way of blending the human profile into the sculptural mass without overtones of the comical, the embarrassing or the ugly.

From the late 1940s Hepworth returned to the *Single Form* motif, but made it indisputably human, and mobile, in distinction to the inanimate stasis of those made a decade earlier. Now the upright acquires a head, and twists and turns. The return to the human figure happened in drawing first; in 1947 Hepworth made a large series of drawings in the hospital theatre, and

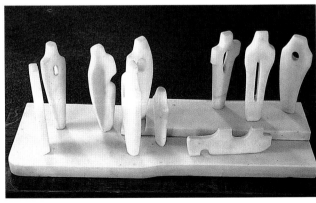

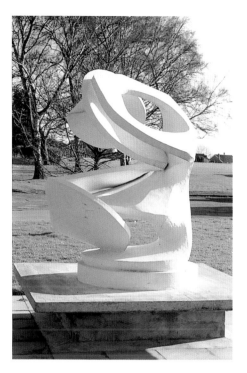

36
*Sculpture with Colour
(Deep Blue and Red)*
1940
Plaster and strings
H.10.5 cm
Tate Gallery

37
Group III (Evocation)
1952
Serravezza marble
H.22.9cm
Pier Arts Centre, Stronness

38
Turning Forms 1950
Reinforced concrete
painted white
H.213.4 cm
Marlborough School,
St Albans

thereafter a smaller series of studies from life. Whether we lay the stress on Hepworth's banishing of the body in the 1930s, or its reintegration in the late 1940s, is open to interpretation.

The blocky human silhouette became quite a leit-motif, and can be traced from the Tate's *Bicentric Form* of 1949 (which prefigures the major commission which was to follow it in 1949, the Festival of Britain's *Contrapuntal Forms*, 1951), through the commission for Hatfield, and *Groups I, II and III*, 1951, to her submission for the Unknown Political Prisoner competition in 1952. The motif can be traced through those works in which Hepworth tried to put into play the sense of the one among the many which represented her understanding of society's mission, and of her role within it.

Hepworth was keen to be further represented at the Festival of Britain, and was additionally allowed to make *Turning Forms* (fig.38) for Jane Drew's restaurant building on the festival site. Hepworth made a case for wanting to be given this chance to realise some of the dreams of the 1930s, and, surprisingly for her, even argued that she would like to work with a woman architect. Both the Festival works were re-sited according to the contemporary concern with placing good modern art in sites where a new generation was growing up; in Harlow New Town and in a school in St Albans. Hepworth admired this ambition, which accorded very precisely with what she and Gabo had envisaged, and her own drawings, in which scenes from the operating theatre are styled *Reconstruction,* are surely symbolic of a wider reading of the need for society to work together according to a rhythm disciplined by a clear objective. Hepworth interpreted the 'grace of living' as deriving from training, which effected the harmony of body and mind. She contrasted the rhythm of the hospital with the loss of rhythm as represented by 'the slapping and pushing of tired mother and frustrated child'. Hepworth literally felt and heard the break in concentration, and one can imagine this may have derived from her own experience of trying to work – and of actually hearing herself work – while looking after her family.

The merging of the human figure in the landscape had for long been a more or less implicit theme in Hepworth's work, but in 1952 it became explicit, almost as if the landscape were the mould for the figure. At first this was shown in small-scale alabasters, then in large-scale stone, as in *Hieroglyph* of 1953. The move to wood, and to the reclining position, in a series of three works from 1955 to 1956, suggested that Hepworth was now burrowing into sufficiently large pieces of wood for them to be treated as mass rather than as verticals. Her use of the hole is no longer overt and expansive. It now suggests the wish to get inside, as much as to open the inside up. It takes us into the darkness, rather than opening up the form to light, as in *Oval Form (Penwith Landscape)* of 1955–6.

A group of large, excavated guarea wood forms from 1955 bears some similarities to these three works, but the balance between the mass and the void is more even. This group has classical names, following Hepworth's trip to Greece – *Corinthos, Delphi, Phira*, and *Delos* – and ends with *Penwith*.

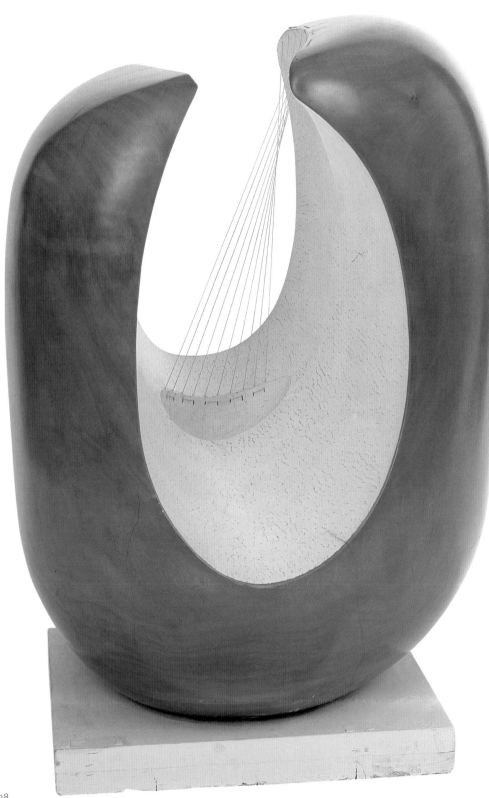

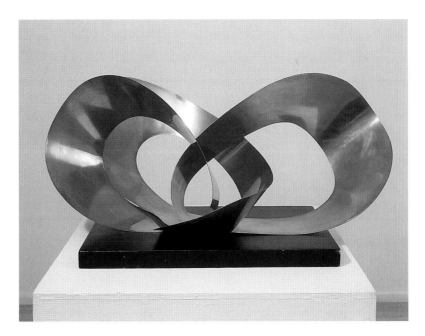

Although somewhat unwieldy, these pieces suggest a resolution of the fear conveyed earlier by the figure in the landscape, and show Hepworth successfully taking her earlier small abstract forms up to the monumental scale without necessarily resorting to the vertical. She exhibited *Hollow Form (Penwith)* (now in the Museum of Modern Art, New York) in an exhibition of artists' statements at the ICA in 1957, with the following poem:

You are I and I am the landscape
I am hollow form and the form is time
Within the hollow palm of this physical world
We touch our primitive image
We contemplate our roots

In 1956 Hepworth suddenly found an entirely different way of 'opening up'; indeed these new pieces were so open that they rather described a line in space, like a drawing, for they had no material interiority. At first she used plaster and concrete, on an armature, to create looping ribbons of line and space. These seven works were given the names of dances – *Pavan*, *Galliard* – and then of song – *Orpheus* and *Curlew*. *Galliard* (fig.40) used sheet copper which effortlessly captured the effect which *Pavan* had laboured to achieve, and the others used sheet brass. *Orpheus* and *Curlew* deployed the stringing technique (appropriate to the titles) to much greater effect, for the strings seemed literally to pull this thin tensile material into shape. The *Winged Figures* 1963, one of which later emerged on the walls of John Lewis' flagship department store in London's Oxford St, also used this combination of brass and strings.

These works in sheet metal seem to act as a bridge between Hepworth's carvings and the incursion of bronze into her work. In the late 1950s, bronze dominated her output, (around twenty-six pieces) though she never stopped working in wood and, to a lesser extent, stone. However, because bronze allows editions, we do see, relatively, a lot more bronzes than if each piece had been a unique cast, and so we probably over-estimate the number of times she used bronze.

39
Curved Form (Delphi)
1955
Scented guarea with
white interior and
strings H.106.7 cm
Ulster Museum, Belfast

40
*Forms in Movement
(Galliard)* 1956
Copper L.76.2 cm
Gimpel Fils

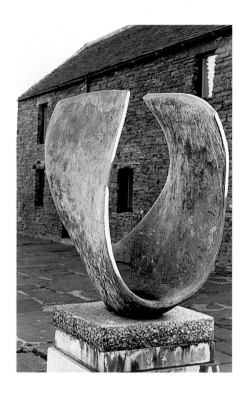

Hepworth is known for her opening up of the form, something which she did much more thoroughly than Moore, and a hint that she was keen to go further in this lies in the gestural freedom of her contemporary drawings, such as *Project for Sculpture* (fig.41) of 1957. At this time Hepworth was more drawn to contemporary painting than to contemporary sculpture, which she found unduly 'neurotic', and, in addition to her admiration for Nicholson's work, she cited Sam Francis, Soulages and the 'Tachistes'. This interest may be detected in her work at this time. Though wood had enabled her to take out more material than stone, bronze allowed her to go even further. Moreover, although preparing for bronze casting involved building up plaster over an armature, it also involved carving into the plaster once it had set, so the bodily involvement was not completely changed. There are a number of pieces from her later career which could only have been realised in bronze, and in this sense she was still being true to her material. The first pieces, *Curved Form (Trevalgan)* of 1956 (fig.42), and *Sea Form (Porthmeor)* of 1958 (both Tate), show the thrust and power which Hepworth was able to capture through bronze. Similarly, the greater linearity of an unusual work like *Reclining Figure (Landscape, Rosewall)* of 1957 relies on bronze's tensile strength. Between 1958 and 1964 Hepworth worked on three major monumental commissions – *Meridian* (fig.16) for a London office block, *Single Form* (fig.19) for the United Nations and *Winged Figure* (1963) for John Lewis's in London – none of which could have been realised without the foundry

If one were to look back to the pre-war period and to Hepworth's professed dislike for 'indirect' ways of working, and find the introduction of bronze surprising, various circumstances can be cited as possible explanations. After the war the exhibiting pattern changes quite radically. Touring shows became more common, and the British Council operated by means of the long-running, international touring exhibition. They preferred bronzes to carvings for this purpose,

41
Summer (Project for Sculpture) April 1957
1957
Ink on paper
35.4 × 25.5 cm
Trustees of the Barbara Hepworth Estate

42
Curved Form (Trevalgan) 1956
Bronze, edition of six
H.91.4 cm
Pier Arts Centre, Stromness

43
Torso II (Torcello) 1958, in the garden of the Hepworth Museum at St Ives
Bronze, edition of six
H.88.3 cm
Tate Gallery

and for an artist who was already worried about not being shown enough, this was a factor to be considered. This, and the ability of bronze to 'save' earlier ideas meant that a number of the bronzes from the late 1950s are essentially versions of carvings from the 1930s (for example *Wave II* and *Ciel*). The drive towards public sculpture was another factor; big carvings took a very long time to carve (as Hepworth had found out with *Contrapuntal Forms*) and were then extremely difficult to manipulate. Bronzes were quicker to make, left less fine work to the assistants, and were less vulnerable in public places. The public sphere had suddenly expanded, what with commissions, travelling exhibitions and outdoor sculpture exhibitions in the parks. This was the sphere in which the artist of the 1950s or 1960s won or lost, and, more particularly, won or lost against Henry Moore. (For a fuller description of the public sculpture, see my chronology in *Barbara Hepworth*, exh. cat., Tate Gallery Liverpool 1994, pp.152–6.)

In the late 1950s Hepworth made an interesting group of bronze sculptures which she called *Torsos*, giving them the distinguishing names of *Ulysses*, *Torcello* (fig.43) and *Galatea*. They are a particularly successful fusion of the human body – its muscularity, its breathing, its upward force – with an almost completely abstract form. These pieces are much more modelled than is usual with Hepworth, and such attention to surface detail brings off the association with a human force. The later *Figure (Nyanga)* (1959–60) is another such piece, although carved in yew, and it is perhaps this use of a different material which proves how much anthropomorphism was part of Hepworth's intention. It seems very forcibly to carry the vigour and breath of the male torso.

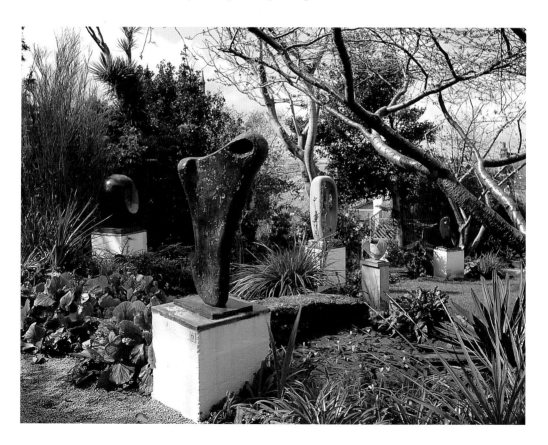

In 1958 Hepworth began a long run of over two dozen very similar stone sculptures – all small scale, under a foot high, mostly in white alabaster and mostly with one hole – which she made until 1962. They are unmemorable and one blurs with another, even when, in 1963, they were put into groupings of two or three. Hepworth's use of bronze only encouraged the growth of small-scale sculpture disseminated by dealers throughout the 1960s for, in particular, the American market. These editions were in polished bronze, to look like brass or gold, and as each was in an edition of eight or ten, even fifteen of these pieces result in a total of 150 such sculptures out in the world. These rather banal, trinket-like pieces (for example *Figure (Chûn)* or *Amulet*, both of 1960) do no credit to the artist, and show how bronze can make things too easy. The same thing happened, but to a lesser extent, with the small carvings that were turned out, perhaps too rapidly, by a team of assistants willing to oblige. Small carvings in black slate began in 1963, and numbered over fifty by the end of the decade. They were generally multiple compositions, rather angular, even bird-like, attractive but unadventurous. Another appealing formula is found in a smaller group from the second half of the decade which used coloured marbles – especially Irish green marble – in opposition with each other and with painted surfaces. The stones are beautiful in themselves, but should not blind us to the weakness of the form underneath. These set the tone for the 1960s, in which the unusual sculptures are rather buried among the host of very repetitive pieces.

The small white alabasters may, however, have led to the rather more ambitious white marble sculptures which began to appear around 1960, significant in scale (from two feet in height, such as *Icon II* in the Ferens Art Gallery, up to five feet, such as *Totem* in the Cass Collection), which offer something new in the crisp, angular delineation of their holes and their shallow surrounds. These marble pieces continued through the decade, and between 1965 and 1973 we can identify over twenty, mostly between two and three feet high, mostly in groups of two, pierced so regularly that they are reminiscent of dominoes.

Around 1966–7 Hepworth used aluminium, and some quite sharp acid colours, to make two spheres. These seem both to reflect current fashion, but also to be part of an ultimately short-lived attempt to bring a sobriety into her work. They were preceded by a work which prefigures their use of colour and their unfamiliar aspect: *Construction (Crucifixion)* (fig.44), which was erected outside Salisbury Cathedral in Wiltshire. This piece almost seems to return Hepworth to some of her pre-war discussions with painters like

Mondrian and Hélion. The spheres might be seen to lead into the *Disc with Strings (Moon)* of 1969. Polished bronze was used in the small but significant group of sculptures specifically dedicated to the sun and the moon (1966–9). They make explicit Hepworth's new interest in the movement of the planets: 'Recently I have been very preoccupied with the relationship of Sun and Moon in relation to sea, as a rhythm.' Some of her carved pieces refer to this interest in the galaxy, setting up parallels between the local Goonhilly radar station and the orbit of the spheres, and Hepworth was visualising her square pieces as large works for hillsides, through which one would see the sky, night and day.

The 1960s are much harder to characterise than the previous decades of Hepworth's work, partly because different strands from earlier years reappear so as to be made in bronze, or on a larger scale. Having more technical assistance, and more money, encouraged Hepworth to come back to things she had been unable to realise earlier. Different things happened simultaneously so that, for instance, the year 1960 saw both the execution of six large wooden carvings – in walnut, elm, guarea, teak and lignum vitae, with colour and strings – and a great many small pieces in stone and bronze. Also, in purely numerical terms, far more sculptures were coming out of the studio – over twice as many as in the 1950s, which had itself been a very productive decade.

The two new ideas which emerged in the early 1960s are the 'Single Form' and the 'Square Form'. The 'Single Form', now flattened out to an almost oblong shape, is a sophisticated interrogation into the difference between line and mass, and was to work perfectly in front of the towering UN building, being both monumental and elegant; representing mass from the front, and line from the side (fig.19). Hepworth made it in various sizes, upwards of three feet, in both bronze and walnut.

44
Construction (Crucifixion) 1966
Bronze with colour, edition of three
H.336 cm
Estate of the Artist at Roche Court Sculpture Park

45
Three Obliques (Walk In) 1968
Bronze, edition of three H.290 cm
University of Cardiff

Overleaf
46
Dual Form 1965
Bronze, edition of eight H.184 cm
St Ives Borough Council

47
Sea Form (Atlantic) 1964
Bronze, edition of seven H.198 cm
Norwich Castle Museum

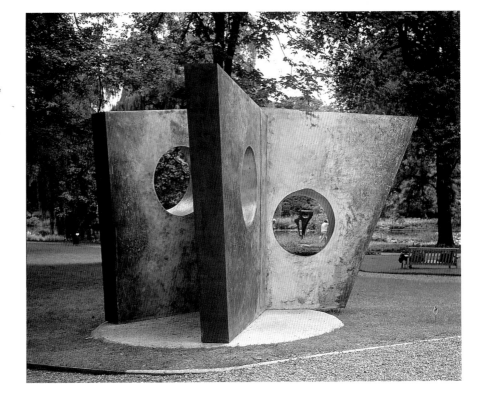

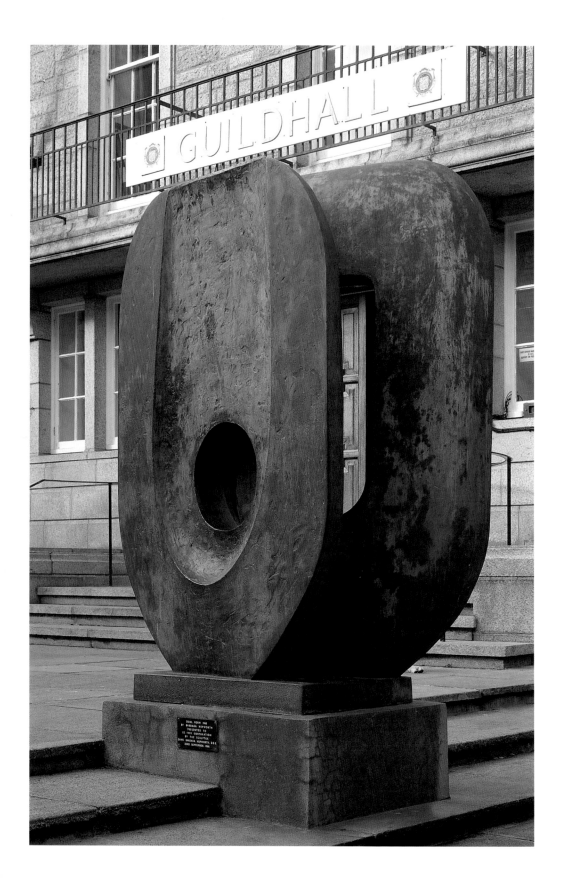

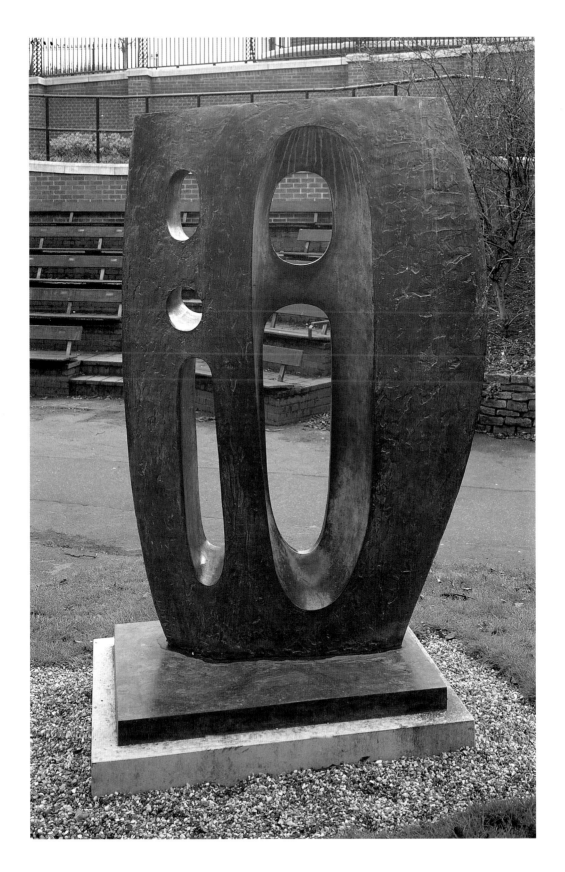

The Square Forms took the tendency of Single Form one step further, and gave Hepworth the chance to work in shallow space by building up a patchwork of overlapping squares. She really played around with this composition during this period; from small to large, from twelve inches to the over life-size, though the form again inspired a number of table-top pieces. It led not only to *Four-Square (Walk Through)* (fig.60) of 1966 (over twelve feet high), but also to *Three Obliques (Walk In)* (fig.45) of 1968 (nearly ten feet high), and their potential for interaction suited their siting as public sculpture on university campuses.

A form that may seem familiar, but which has in fact been refined quite differently, with a very successful result, is the deep 'U' shape which we see in *Dual Form* (fig.46), another large piece known from its dispersal on public sites around Britain. The variations on *Dual Form* date from 1965, but clearly go back to *Curved Form (Oracle)* of 1960, and *Two Forms with White (Greek)* of 1963, both in wood and paint. The 'U' shape takes further the more familiar aureole around the hole and, in slicing off the top, suggests a kind of infinite extension of the sculpture. This adds to the spectator's involvement with the piece, a concern which was important to Hepworth at this time, and which shows that she was not unaware of what was happening in the work of younger colleagues, such as Anthony Caro and Phillip King, and of the move to bring sculpture down to ground level.

In 1962 Hepworth was interviewed for *The Studio*, and pointed out:

It is easy now to communicate with people through abstraction, and particularly so in sculpture since the whole body reacts to its presence … people become themselves a living part of the work.

48
Lotus 1973
White marble
H.77.5 cm
Private Collection

49
Three Part Vertical
1971
White marble
H.175.3 cm
Private Collection

50
Assembly of Sea Forms 1972
Marble mounted on stainless steel
H.108 cm
Norton Simon Art Foundation, Pasadena, California

The last working idea which might be identified as innovative within this over-productive decade of the 1960s is the *Rock Form/Sea Form*, which used bronze to create an almost leathery outer shell, punctured by holes like bubbles in oily water. These two pieces, from 1964, both around six feet high, refer back to the massive *Figure for Landscape* of 1960 but, unlike it, have shed the Moore-like overtones of the hooded figure. They allow the viewer to 'enter' the piece, if only metaphorically, without being engulfed in figurative associations.

I have referred already to the developing series of medium-scale white carvings. A few of these stand out as really interesting. One or two, such as *Two Faces* of 1969, are rather bold in their use of the drill marks used to split the stone, and *Lotus* from 1973 (fig.48) is unusual in suggesting the template or section of a sliced piece of marble. Such references to the 'raw' stone, or to some kind of previous use – as if forgotten to modern man – are rare in Hepworth. In a small series of totemic forms she went further, making *Three Forms Vertical (Offering)* in 1967, which was one of a kind until 1971, when she again tried piling white marble forms on top of each other with *Three Part Vertical*, (fig.49), *Horizontal Vertical* of 1972 (in the Norton Simon Collection, which attempts to build a base into the sculpture), *Cone and Sphere* of 1973 and two *One, Two, Three (Vertical)* pieces from 1974–5. These give a slight impression of being unfinished stones, but are in fact quite smooth, balanced, apparently precariously, on top of each other, and showing an interest in what supports sculpture which both dates back to early modernism and also reflects British sculpture of the 1960s and 1970s, and in particular works by William Turnbull and Barry Flanagan.

Towards the end of her life, Hepworth produced four multi-part composi-

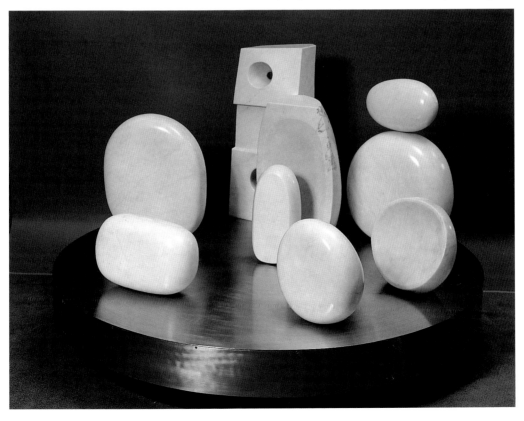

tions: two for outdoors – *Nine Figures on a Hill* of 1970 (fig.66) and *Conversation with Magic Stones* of 1973 (fig.59) – and two for indoors, *Assembly of Sea Forms* of 1972 (fig.50) and *Fallen Images* of 1974–5. Though they share a kind of conversational or family attitude, these pieces are formally rather distinct. *Nine Figures on a Hill*, though in bronze, refers directly to the stacked marble pieces in its irregular rhythm of smooth and ridged surfaces, holes and planes. The figures are semi-mechanistic, semi-animate, slightly turned, as if responsive. They remind one of American Indian carvings (and not only in their titles), of Mexican terracottas, and of the later sculpture of Max Ernst, of Germaine Richier's *Chessboard* or Isamu Noguchi's *Family*. The whole *Family of Man* (as *Nine Figures on a Hill* is also called), can be seen ranged up a slope in the Yorkshire Sculpture Park (fig.66).

Conversation with Magic Stones comprises six pieces, and is less confrontational than the *Figures*. The profiles of its components are like the silhouettes of the early 1950s, such as *Concourse* of 1951 and others. Its components are brought closer together, but they make a space, which the viewer needs to enter in order to complete the conversation. This space, perhaps especially in the garden of Trewyn studio, does indeed have an air of magic. These two compositions bring us to the end of a long conversation Hepworth had been having with herself and with her art: how to work out and work in an air of secrecy and of discovery to the viewer's experience of the sculpture. Though she had long been interested in the special places the spectator will go to in search of sacred images or the special places in which they come across secret images, by chance, it took her until the very last few years of life to solve this problem by making her own special place, within the sculpture itself.

Two last pieces are often read as providing a kind of coda to Hepworth's oeuvre. *Assembly of Sea Forms* was finished in 1972, and we presume we see it the way the artist intended. This group (Norton Simon Collection) comprises eight pieces assembled on a turntable. *Fallen Images* was left unfinished at the time of Hepworth's death in 1975, but is nevertheless displayed at the Hepworth Museum, and comprises six pieces. Both are in white marble and *Sea Forms* at least is somewhat reminiscent of the subtle way in which she carved marble in the mid 1930s. At any rate it seems composed, and rather like the *Family of Man* in its attitude of frontality. *Fallen Images* bears an uncanny resemblance to similarly unfinished configurations in Brancusi's studio, as recorded in his own photographs. Could this be some kind of homage or reprise on Hepworth's part? It is also oddly insistent upon its likeness to a wooden model Hepworth had made for a monument to the Spanish Civil War (1936–7), with its various parts dismantled, as they were stored in the studio in St Ives.

The title of *Fallen Images* is intriguing, and leads us to ask, are these the same forms which were previously stacked up in twos or threes (see *Cone and Sphere*), but which have now been brought down to the ground, lost, or loose, randomly circling a centre which might have once served as their support? Why have the images fallen, and what does that mean? *Fallen Images* is not a great sculpture – nor a reliable one, for we cannot be sure how the artist left it and named it – but it does send us a helpful backwards glance over her late work, and help us to read some meaning into what is otherwise obtuse. It questions both the formal make-up of sculpture, and its power. What kind of physical and mental support does sculpture need to be effective in our world, and are we able to recognise it?

3
A Critical History

Hepworth's critical fortune was rather diverse, and changed gear several times through her long career. In some ways she was more popular at the beginning than at the end, and it is certainly true that she was written about by better critics in the early years. This has meant that even now, if we talk about the Hepworth of the post-war period, we often do so in pre-war terms. It was the writers of the 1930s who found a language for Hepworth's sculpture which has come to be indissoluble from her work.

At the end of her career Hepworth was certainly honoured by the British establishment; she was created a Commander of the British Empire in 1958, and soon began receiving honorary degrees and fellowships from universities all over the country. In 1965 she was made a Dame in the Queen's Birthday honours list, and acted as a trustee of the Tate Gallery for the next seven years. Yet, despite these official accolades, her critical reception was often lukewarm.

A reading of the reviews of the 1950s would suggest that her work no longer struck a chord with a new generation of viewers. However, one must be wary of taking a handful of critics to represent 'the viewer', and remember that in other ways this period represented Hepworth at her most successful, as many patrons, and in particular universities, all over Britain and abroad, bought her work to place it in public view.

Hepworth's exhibiting history really began during the war itself. After five small, rather private exhibitions in dealers' galleries in London, she opened up to a broader public in Yorkshire, first in Leeds in 1943 and then in Wakefield and Halifax in 1944. After the war she returned to 'base', her London dealers Reid and Lefevre, with whom she showed four times between 1946 and 1952, but these years are notable for activity elsewhere as well. She had her first show in New York, another exhibition toured America, and she represented Britain at the Venice Biennale. However, her most important exhibition was surely that at London's Whitechapel Gallery in 1954. One might suggest, therefore, on this kind of evidence, that Hepworth became a 'popular' artist after the war.

Moreover, the books on Hepworth all appeared after the war. William Gibson's monograph of 1946 was the first book dedicated to her, and was followed in 1952 by *Barbara Hepworth: Carvings and Drawings*, which had a preface by Herbert Read and has remained the standard monograph, mainly because of the artist's own involvement. A.M. Hammacher's 1958 book *Barbara Hepworth* was not only published in London and New York but also in foreign language editions in Amsterdam and Cologne. The 1960s saw the catalogue of works, a book about the drawings, and two more monographs. Nevertheless, aside from this flurry of activity, one could say that a list of monographs that

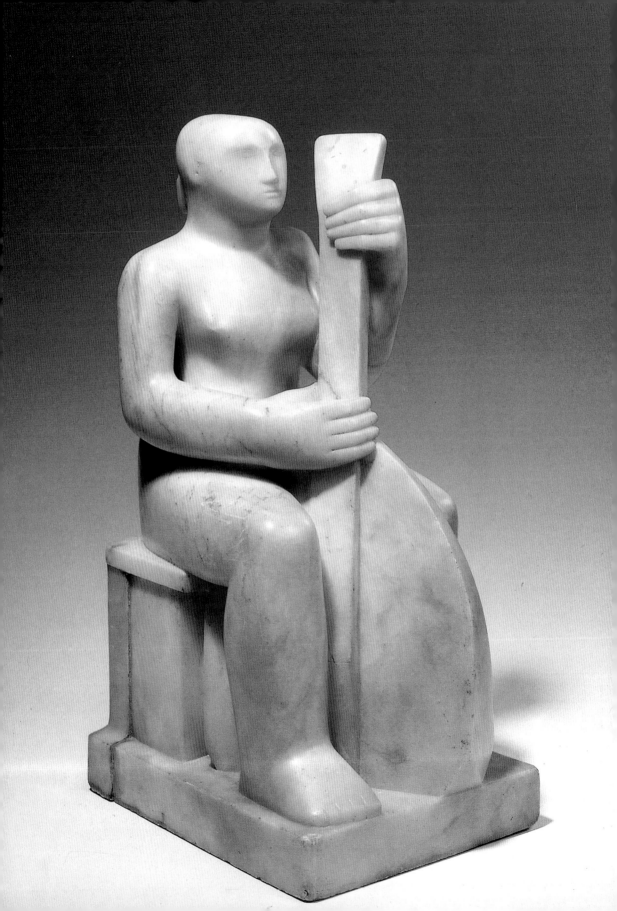

runs to little over a dozen – in a period of fifty years – is surprisingly small for a sculptor of such achievement.

This brings us to the nub of the question. Is there a problem with Hepworth's work itself, with writing about Hepworth's work, or with the people who were writing?

Hepworth received press notice at the very beginning of her career when her submission for the Rome Scholarship was covered (at least twice) by the papers. She began carving directly into stone in the mid-1920s. As already discussed, she and Skeaping were both known for their direct carving, and were part of a recognised trend at the time. Moreover, it was a trend that was particularly identified with women sculptors. By the end of the 1920s it was an established part of 'art-talk' that sculptors would want to keep their work in their own hands from the beginning to the end of the process, and that this necessitated a kind of collaboration between the artist and the material. Thus on their return to Britain from Rome in 1926 Hepworth and Skeaping readily found their place within current critical discourse.

They had a studio show in 1927, another joint show with their fellow Rome scholar William Morgan at the Beaux-Arts Gallery in 1928, and took part in two group exhibitions. The Skeapings's works in all three gallery shows were favourably reviewed in *The Times*. Other newspaper critics soon noted their contribution and they were included in more specialist reviews of contemporary British sculpture. Hepworth's contribution to an exhibition at Selfridge's Roof Garden in 1930 was mentioned in the *Morning Post*, *The Times* and the *Connoisseur*. The acceptance of direct carving and truth to material was so well established by the end of the decade that some critics had begun to weary of it. It may have been the very tameness of the movement as it had matured that pushed Hepworth to go further and, in doing so, to alienate those critics who had enjoyed her more tentative early works.

Hepworth had her last joint exhibition with Skeaping in 1930 at Tooth's (though they were to appear together again in group exhibitions up until 1932). This show got reviews in at least eight national newspapers, all of them good. Her next show, two years later, was also at Tooth's, and was another two-person show, but with Nicholson rather than Skeaping. It received much less favourable press coverage. Hepworth had come to the parting of the ways, and with it she relinquished the goodwill of the more conservative press. She had to find a different kind of critic, who would write in a different kind of publication. This new 'space' was the preface of the little catalogue, and it introduced into Hepworth's career the writer Herbert Read, who was to write more prefaces for her than anyone else over the next twenty-five years.

The catalogue preface was a genre that was only just developing, and it grew hand in hand with the exhibition catalogue which had begun as little more than a handlist of titles and prices. Hepworth found a number of 'different kinds of critics' to introduce her work in the catalogues to her exhibitions, including the physicist and crystallographer J.D. Bernal (who was Margaret Gardiner's partner) and the painter Patrick Heron. Though Hepworth could choose how to introduce her work if she had a catalogue for a show, she had less control over who might review it. Nevertheless, some of her friends did write reviews, and some other reviewers probably became friends by reviewing her work. These included the painter Paul Nash, the art historian Henri Frankfort (who bought her 1933 *Two Forms*, fig.52), the architect J.M. Richards, and the artist Naum

51
Musician 1929
Alabaster H.45.7 cm
Private Collection, USA

Gabo. Herbert Read wrote a number of reviews, including some for French magazines such as *Cahiers d'art* and *XXe siècle*.

Another strategy which Hepworth made use of was to write about herself. Indeed, two of the earliest texts which we have on the artist are her own: her interview in *Studio* of December 1932, and her statement in *Unit One* of 1934. Hepworth's *Unit One* text was written with the help of Adrian Stokes in December 1933; his own text on her had come out the previous month. Three years later *Circle* was published, like *Unit One* essentially an artists' publication written by artists for artists. It allowed them to describe their aims as they wished, and even to design and print the publication in accordance with those aims, and Hepworth's statements should be understood as part of a wider trend for artists to represent themselves.

Although in general Hepworth no longer received coverage in the mainstream press, her work did inspire a few remarkable pieces of writing in the 1930s, chief among which must be the only text Adrian Stokes wrote about her, a piece called 'Miss Hepworth's Carvings' which he wrote for the *Spectator* while he was standing in for its usual art critic, Anthony Blunt. Stokes had already made public his almost obsessive enthusiasm for Italian Renaissance art in *The Quattro Cento*, published in 1932. His famous hymn of praise to stone, and to stone and water, as embodied in the shallow relief carving on the Tempio Malatestiano, was published as *Stones of Rimini* at the beginning of 1934 and was finished at the time he was writing on Hepworth. For Stokes, carving was essentially about the relief, about thinning, flattening and rubbing, and thus it is incongruous that he made the effort to incorporate Hepworth's very plastic forms into his conception. 'Miss Hepworth's Carvings' is not so much a review as a poem. Though it is short, it is sustained, and is a shorter version of *Stones of Rimini*, which makes the reader see and feel the artworks through the writer's eyes, as if by force of wish fulfilment. Stokes points out the presence of the 'mountain' alongside the 'mother-and-child' and, more famously, stressed that 'Miss Hepworth's stone is a mother, her huge pebble its child'. Stokes is exceptional in finding a way of talking about the bond between the sculptor who was a woman and a mother, and the special power that carving gave her, and which she gave carving. Though truth to material was already developed as a concept, only Stokes thought to elaborate the poetic notion of the 'stone-shape' which reappears in Hepworth's *Unit One* text.

Stokes was in analysis with Melanie Klein for most of the 1930s, and when Hepworth stayed with him in Cornwall he had only recently come out of it. The pieces that he wrote for the *Spectator*, not only on Hepworth but also on Moore and Nicholson, all make a point of the possessive relationship between the artist and their work – 'Miss Hepworth's Carving', 'Mr Ben Nicholson's Painting', 'Mr Henry Moore's Sculpture' – and one might see Melanie Klein as being behind such a view. In 1933, before he reviewed Hepworth's work, Stokes had reviewed Klein's *Psycho-Analysis of Children*, and one could hazard that not only did Stokes push the Kleinian use of play-technique into his reading of Hepworth's work, but that Hepworth was herself interested in this, and studied her children's art within a context of discussion about the unconscious urge to form.

The introduction to Hepworth's first solo exhibition catalogue in 1937 was written by the scientist Bernal, and in it he referred to her introduction of a fourth dimension, 'a closed curve in time', an interest shared by many abstract artists in these years. Bernal's brief written engagement with Hepworth's work

52
Two Forms 1933
Blue Armenian marble
L.71.1 cm

Whereabouts unknown

brought him close to her, and they kept in touch even when Hepworth had removed to Cornwall, for Bernal had war work which took him there. They had a fruitful correspondence about the similarities and differences of scientific and artistic laws. Hepworth expressed to Bernal how her reading of artistic laws extended well beyond sculpture: 'trying to live the sort of life that will most easily enable us to express the laws – that is construction.' Bernal also contributed to *Circle*, and his own stated wish to bring art and science into the mainstream echoed Hepworth's desire for a 'clear social solution'. However, during the war Hepworth became more uncomfortable both with Bernal's Communist position – which led Hepworth to assume that he would now see her art as useless – and with her empirical experience of where science was leading. She may have had doubts about a 'machine age', but her principal point was that art and science should move forward together.

From the beginning of the war Hepworth was thrown into a more introspective period, during which she was evaluating some of her group's earlier thinking. It could be that this was marked by a more conscious and creative relationship with her children, which helped her to understand her own works as 'her own works', and to situate them within her context of the Cornish landscape and its focuses. She later described these years as 'the most vital time of her life', and her use of that key word 'vital' emphasises the importance of lessons learned at this time. Anchored in a small community, far from the capital, Hepworth was in a position to be both subjective and objective about cultural change, and was optimistic that a new phase would emerge from the contemporary flux. She shared such thoughts in her correspondence with the artist and writer E.H. Ramsden, who reviewed her 1943 Leeds exhibition in *Horizon*. The correspondence between the two goes back earlier, and in 1941

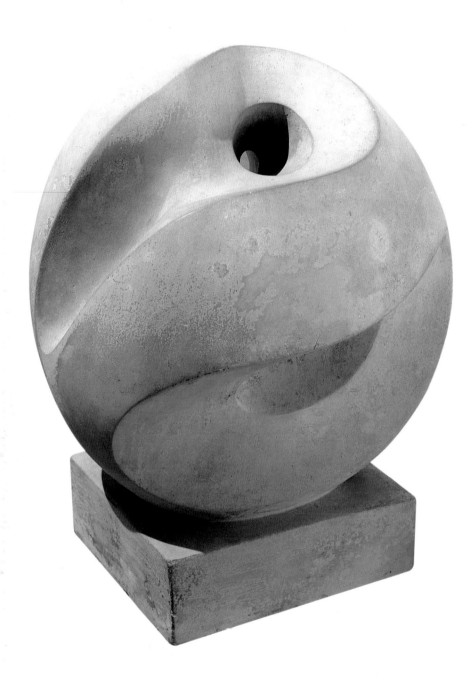

53
Helikon 1948
Portland stone
H.76.2 cm
Museum of Modern Art,
New York

54
Involute I 1946
White stone L.26.7 cm
Private Collection

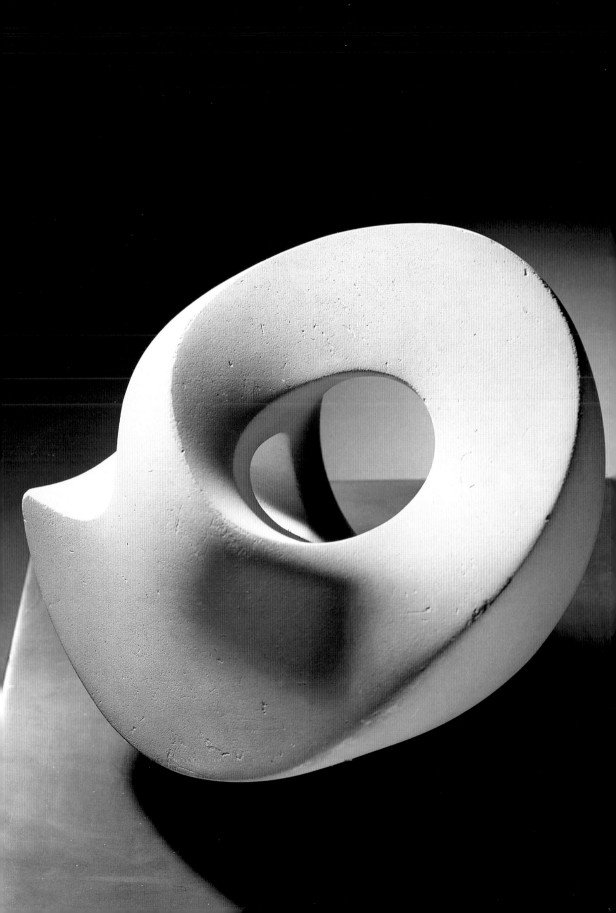

Hepworth told Ramsden how much she liked her writing – 'Personally I never believe in simplifying for the general public – but all these men say it's essential'. Hepworth and Ramsden seemed to meet on the formal plane, at the cross-over between stillness and expansion, movement and stasis. Ramsden's terminology of 'limited within – unlimited without', and her idea of converging 'towards a point of repose' struck a chord with Hepworth in the early 1940s just as Stokes's stone-shapes a decade earlier had accorded with her own sense of direction. I believe one can see those works which create a sense of perpetual, but limited, movement, like *Oval Sculpture* (fig.1), *Hollow Form* (1944), *Helikon* (fig.53) and *Involute I* (fig.54), as arising from this critical dialogue.

Ramsden included Hepworth in her sculptural survey books, wrote an article on her in 1946 in *Polemic*, and included her in the magazine she founded in 1950, *Eidos*. Despite this, their friendship was in jeopardy. This certainly had something to do with the change in Hepworth's work, but perhaps also in her outlook, which was becoming more worldly. During the war Hepworth and Nicholson were hoping that Ramsden and William Gibson would compile a book on Constructivism, with Gabo and Read, but the project, and all the personal relationships it entailed, were under strain, and Gabo left for the States in 1946. As it was, Gibson, a keeper at the National Gallery, went on to write the first monograph on Hepworth, which appeared the same year. This circle of friends and colleagues all recognised this time as one of transition, represented perhaps by Hepworth's 'involute' sculptures. That she then moved on to make her most figurative works must suggest that she had decided to react in a manner which she knew must mark their decisive split.

At the end of the 1940s the critic Josef P. Hodin appeared on the scene, reviewing Hepworth with comparative frequency in a range of magazines both in Britain and on the continent of Europe. He was no newcomer to the British scene, and to a certain extent he was perhaps following in Read's wake, being the Librarian at the ICA where Read was President. In 1961 Hodin published a monograph on the artist which has since become more famous for its catalogue of works compiled by Alan Bowness. Unlike previous writers on Hepworth, Hodin was truly a professional, and international, art critic. He also wrote on Henry Moore but never, unlike Read, measured Hepworth against some unattainable objective as represented by Moore. Hodin picked up the transitory/permanent dichotomy recognised by Ramsden, and placed it in the broader context of post-war crisis. He gave Hepworth's work a sense of actuality, of particular time and place, of a fixed point responding to a transitional world. Hodin and Hepworth understood the 'constructive' idea similarly, so that Hepworth's idealism could be more generously contrasted to Moore's sense of tragedy.

In 1948 Henry Moore represented Britain at the first post-war Venice Biennale. The Biennale, which had begun in 1895, was an opportunity for a country to showcase their best artists and even to change foreign perceptions about the modern art of that country. The British Council, founded in 1934, took on the Biennale with great determination. With Moore they effectively challenged Italian, French and German views that Britain and modern art did not go together. So successful were they indeed that Moore remained their principal export for the next twenty-five years. Hepworth had the honour and, as it transpired, the misfortune to be their choice for the 1950 Biennale. The Italian commissioner was mainly concerned to have paintings by Constable, and aside from that was happy to have a group of contemporary British artists, including Matthew

Smith, Graham Sutherland and Paul Nash. However, the British Council, in the person of Lilian Somerville, pushed for a more restricted selection, and one which would include Hepworth. She got her way, and eventually Constable was accompanied only by Smith and Hepworth. In retrospect, both Somerville and Hepworth, who were friends, may have had cause for regret. The timing of Hepworth's presentation on the European stage was not at all good, and she very much fell under the shadow of Moore. She was understood to be Moore's disciple, but 'this year's holes are not appreciated'. Hepworth's time in Venice was further complicated by Nicholson's presence at the time their marriage was breaking up. He was there unofficially, but apparently expected official acknowledgement from the British Council who had chosen Hepworth ahead of him for Venice.

By this stage in her career Hepworth had friends in high places. Such friendships did not, however, necessarily secure the best treatment. Perhaps Somerville's personal friendship obscured a more objective judgement of what it might mean for Hepworth to be shown in Venice after Moore. Moreover, her friendships with people who had now arrived at the top of the ladder sometimes only undermined Hepworth's confidence in their true appreciation of her work. This is surely true of Herbert Read, who was on the selection committee for Venice, as he was for most exhibitions and activities within the world of contemporary British art.

Hepworth's – I believe, justified – concern about Read's motives, and about his real appreciation of her work, is voiced in a letter she wrote him in 1952, in which she asked whether, when he excused himself for his introduction, he was saying that he could not be objective about her work because she was a woman, or because he liked her 'as a person so much more' than he liked her work. Though Hepworth did appreciate in Read his equable recognition of both male and female attributes, this momentary hesitation seems to hint at a larger problem. Read clearly had found it much easier to be wholeheartedly enthusiastic about Moore after the war, as did another influential figure, Philip Hendy, now Director of the National Gallery, who had given Hepworth her first retrospective exhibition, at Temple Newsam in Leeds, during the war. Read's later prefaces, when he even agreed to write them, are distinctly lacklustre affairs, clearly written without real commitment.

After the Venice Biennale, Hepworth moved to a new dealer, Gimpel Fils, and developed a close relationship with the Gimpel family. She had exhibitions which were reviewed, but the tone of the reviews was hardly enthusiastic, and Hepworth was quite conscious of this. She was described (in the *Sunday Times* in 1955) as 'The Sheraton among modern sculptors', an image which quite clearly brings out the combination of elegance, skill, quality and perfectionism – which critics were ready to acknowledge – with something that was cold, austere and unmoving. Perfectionism was, after all, only achieved through a single-mindedness which the critics seemed to equate with the inhuman. Hepworth seemed to have a fatal knack of being written about by people who were ambivalent about her work; Heron called her sculptures 'superbly cold, calm, faceless' and in his introduction to her 1951 exhibition contrasted this with the depth of human feeling in Moore.

The 1960s however brought in a new generation of critics alongside J.P. Hodin: Norbert Lynton, Robert Hughes and Edwin Mullins, who not only thought that Hepworth was undervalued, but could reinscribe her works as romantic or lyrical. The turnabout was almost total; whereas the 1950s writers

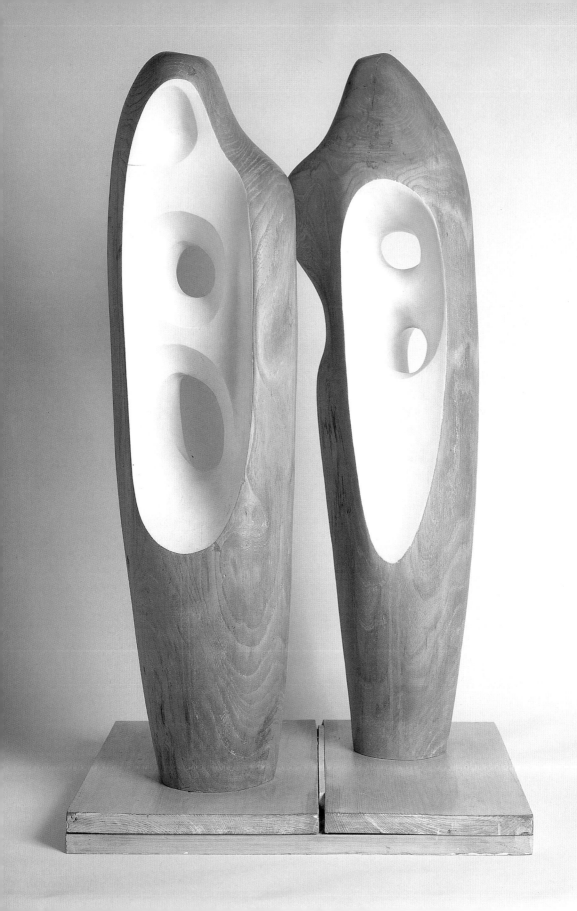

were uncomfortable at connecting a woman with work which they saw as cold, the 1960s critics were able to identify a physical relationship between a woman and work that was sensual.

In 1962 Bryan Robertson, one of Hepworth's most effective post-war champions, arranged her second exhibition at the Whitechapel Art Gallery in London, this time of seventy-six works from the previous ten years. It is worth highlighting the fact that this exhibition only went back ten years to 1952; at this point Hepworth's work could still be seen very much as current. Perceptions change however, and it was only six years later, at the age of sixty-five, that Hepworth had an enormous and complete retrospective exhibition at the Tate Gallery. It was probably too large: 226 works made the Tate's central Duveen galleries look overcrowded, and the critics were affected by this. (This may have been due to the artist herself; on the evidence of her correspondence over Venice she tended towards more rather than less, afraid of what she termed 'discreet' and 'ladylike' effects!) The Tate show was a kind of endnote to contemporary writing about Hepworth; she had now definitely become a historical figure, rather than a contemporary one. It also gave critics a chance to see the works Hepworth had made in the 1930s and 1940s, and to judge them preferentially.

This verdict corroborated the effect of a slightly earlier show – at Marlborough Fine Art in 1965 – which looked at *Art in Britain 1930–40 Centred Around Axis, Circle, Unit One*. The preparation for this exhibition, at which she was represented with twenty pieces, had affected Hepworth, who now began to see herself as a historical figure, with her strongest card (and the one that was perhaps easiest to play) being the pre-war work.

One way of playing this card was to publish a fuller chronology than had hitherto been available, and this Hepworth did in the *Pictorial Autobiography*, published in Britain and in America in 1970, a tremendously influential book on the way that she has been understood. But in fact Hepworth had always taken a very active role in writing about her work and in the way that the public would receive it. Looking back over the major monographs – Read's of 1952, Hodin's of 1961 and Bowness's of the drawings in 1966 and the sculpture in 1971 – and exhibitions – at the Whitechapel in 1954 and 1962 – we find that all of them closely involve the artist, either in actually writing the text or in conversations.

However, at the very moment at which Hepworth seems to have decided to make more play for her historical position, a new kind of critic was becoming interested in her work, for different reasons. At the end of her life there was a modest, but distinct upturn of feminist interest in her work, especially in America. The first hint of this was probably a 1969 review by Cindy Nemser, better known for her interviews with Eva Hesse. Shortly before her death Hepworth gave four interviews – notable among the few such published – to women, and specifically feminist, writers, including two with Nemser for *Feminist Art Journal*. This was followed by her inclusion in the big surveys of women artists that began to appear, particularly in America, between 1975 and 1978, and then again in 1991. Such surveys will have introduced different people to Hepworth, and for different reasons.

Despite this early interest from American feminist writers, the years after Hepworth's death in 1975 were fallow, however they are measured. Aside from some dealers' shows, there were very few museum exhibitions devoted to her work. Indeed, in the twenty years after her death, the only exceptions have been relatively small exhibitions in Edinburgh, the Yorkshire Sculpture Park, Swansea and Wakefield. It is perhaps more significant to look at group exhibi-

55
Two Figures 1947–8
Part painted elm wood
H.121.9 cm

Frederick R. Weisman Art Museum at the University of Minnesota, Minneapolis, The John Rood Sculpture Collection

tions, and the kind of exhibition that absorbed her. She was inevitably included in a whole rash of English shows devoted both to the 1930s and their artists' groups – *Unit 1* and *Circle* – and to St Ives, but was rarely included in the more important, international surveys, the notable exception being Albert Elsen's 1979 *Modern European Sculpture 1918–1945*.

In the last decade or so Hepworth's reputation has surely been influenced by the strong wave of interest that the public has shown in St Ives. Twenty-five works by Hepworth were shown in the exhibition organised by the Tate in 1985, and since then interest in Hepworth has been connected to a wider interest in the whole community of artists and the St Ives phenomenon. Her museum had opened in 1976, and after the Tate Gallery at St Ives opened in 1993, it began to receive many more visitors. In this way, Hepworth has continued to be understood within the framework of St Ives and its artistic community, and, if anything, the two have been bound more inseparably together.

Indeed, if one looks through the bibliography of literature on Hepworth, one is struck by the fact that its range has become steadily more national since the 1960s. At the beginning of her career its base was British, but by the late 1930s, with Carola Giedion-Welcker's seminal *Modern Plastic Art*, the stage was set for a more European dimension. After the war, in the early 1950s, the focus of the literature was both European and American. This dimension died down through the 1960s, and the studies on Hepworth became at once more localised; either national or fragmentary. The surveys in which she is now included are either premised on the female or on the British, and more specifically the Cornish.

With this hiatus from the early 1970s to the 1990s a whole generation of 'art lovers' could easily never have had the chance to see any survey of Barbara Hepworth's work, never mind a retrospective, other than by visiting the museum in St Ives. This fact confounded the view of critics at the time of her death, as they themselves were swift to acknowledge. We need only compare two statements from the same critic, William Packer, a decade apart. In 1976 he wrote: 'No doubt large and ambitious exhibitions of the work will be mounted at intervals in the future', and in 1988: 'Since 1975 her reputation has been not so much neglected as critically dormant through the protracted Grand-Old-Manhood of Henry Moore'.

When Hepworth died, Moore wrote an 'appreciation' in the *Sunday Times*. It was notably ungenerous, and goes some way towards justifying the concern about the invidious nature of their relationship which had occupied Hepworth, perhaps unprofitably, in the later years of her life. Moore lived on a decade after Hepworth, in rather better health than she had enjoyed at the end of her life. He was able to set up a Foundation, which has ensured the continued dissemination of shows devoted to his work, at home and abroad, as well as the sponsorship of many and wide-ranging exhibitions. Though Moore's star is not necessarily high in the critical eye, it has never been allowed to wane. He is not linked to Hertfordshire, where he went, like Hepworth, when war drove them out of London. Moore is somehow more absolutely part of universal experience. Hepworth, on the other hand, has become more and more part of the 'St Ives experience'. She is more readily associated with the 'Cornish' than with the 'English'.

Ironically, one of the exhibitions which the Henry Moore Foundation supported was that mounted at the Tate Gallery in Liverpool in 1994, a Barbara Hepworth retrospective. This exhibition (with which I was involved) included less

56
Barbara Hepworth in
1955

than half the number of works shown at the previous retrospective, also at the Tate (in London), in 1968, but was still a unique opportunity for a new generation simply to see what Hepworth had made over her long career.

The 1994 exhibition took Hepworth out of the contexts which had predominated during the 1980s: English pre-war modernism and St Ives. It was a chance to see her work, from the beginning to the end, on neutral ground. A more broadly based premise, promoted as something 'new', invited in a new generation of art historians. As part of this, a Critical Forum was organised, which was published in 1996 (see bibliography), and brought together twelve rather diverse contributions, which begin to indicate possible future directions of study, and an invaluable bibliography compiled by Meg Duff. Indeed, it may be the bibliography which will prove to be the most useful part of the book in providing the factual basis for more widely ranging accounts of the artist.

Shortly after the 1994 retrospective, the first biography of Hepworth was published. It was not an authorised biography, and perhaps for this very reason people looked forward to a new emphasis, as well as some revelations. This was not the book's aim however, and because its author, Sally Festing, had not been allowed access to Hepworth's papers, the anticipated authorised version, by Sir Alan Bowness, will be the best chance for filling in all the many gaps left in the accounts so far. As those accounts were prepared by the artist in collaboration with Bowness, it will be interesting to see to what extent his new account will expand or revise what they say. Hepworth has perhaps escaped the critical grasp because of her very fusion of herself as subject and object. Rather than dismissing this duality, we should recognise and address it.

4
Current Contexts

It is always hardest to be objective about the present. How is Hepworth regarded now? What is, and what is the nature of, her current standing? The artist's own words continue to be tremendously influential in our reading of her work. One could argue that this is as it should be, and that we are lucky to be dealing with an artist who was not only very articulate but also quite tidy-minded in grouping different sections of her life into discrete categories. Hepworth did our work for us. However, this meant that a lot was left out, and the emphases she chose to make, and why, must be looked at closely.

Another factor which has led to the seamless nature of the presentation of the 'Hepworth' story is that by the early 1960s she was collaborating with her son-in-law Alan Bowness, who went on to become Director of the Tate Gallery, which in 1980 took over the running of what had originally opened in 1976 as the Hepworth Studio and Garden Museum. Hepworth had collaborated with Bowness on compiling her catalogue, and on the later monographs, so that her death made relatively little difference to the way her work was described.

The Tate Gallery has a special relationship with Hepworth and plays an important role in how she is perceived. The gallery owns a very large number of her works — more than any other collection anywhere. Hepworth gave some of these herself: four sculptures in 1964, and a further nine pieces three years later. Others were given by her estate after her death, in part at the time of the hand-over of the Hepworth Museum. No other artist has a dedicated museum within the greater fold of the Tate.

In striking contrast with France there are very few studio museums in Britain and thus the Hepworth Museum stands out even more, since few other British artists are viewed so completely within the context of one place. This place has, of course, many layers. First of all, perhaps, Hepworth is seen in the context of the house where she lived (and died), the studio where she worked, and the garden which she created. Then she is seen in the context of the narrow, winding streets of the town where she lived, with its framework of beaches and sea. Next, she is seen as one artist among others, and even if she was one of the most famous, she nevertheless lived in a context of artists.

Now that the Tate St Ives has opened, some twenty years after the Hepworth Museum, this context has been rather formalised. Hepworth is now quite clearly only one among others, though we can, if we want, seek escape from the Tate's lucid logic and retreat to the romantic garden of the Hepworth Museum. Since the tickets for the two galleries can be combined, a relatively high proportion of visitors to the Tate St Ives also go to the Hepworth Museum. The latter offers a quite different, much more private experience. Perhaps the

57 and 58
Trewyn studio,
reorganised as the
Hepworth Museum
and Sculpture Garden

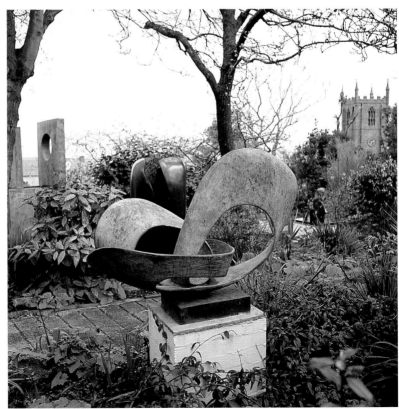

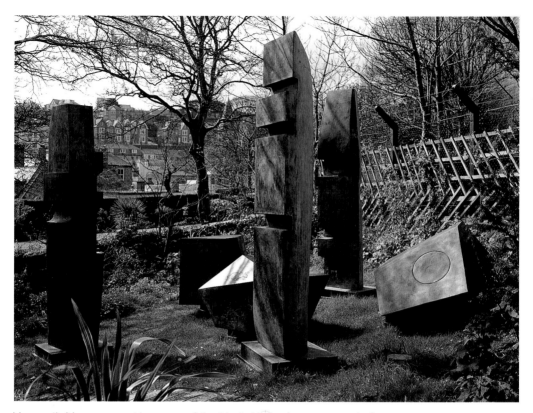

Hepworth Museum provides more of the kind of intimacy one expects from a visit to an artists' colony, to a special place.

The story of the museum itself deserves description. The works were laid out by Alan Bowness with the then Director of the Tate Gallery, Sir Norman Reid. The attempt was to make a domestic museum, not to recreate Hepworth's domestic circumstances. Although there have been minor changes, the basic layout of the installation has remained the same ever since. It presents an oasis of calm – white inside, green outdoors – hidden away by its high walls from the holiday town around it. Its white modernist aesthetic will remind some visitors of Jim Ede's house which has now become the Kettle's Yard Museum in Cambridge; both give an impression of art and life combined in quiet and tranquil unity. Some of this is certainly true and, by any calculation, the Hepworth Museum effectively provides a very pleasant experience, both for looking and for simply sitting. However, its bias towards the quietly ordered and the private means that it is all too easy to forget the hustle and bustle in which Hepworth herself was involved, and how she, and her assistants, were busy running a business with an eye on London and New York.

The first curator of the Hepworth Museum was Brian Smith, who had been Hepworth's secretary. He looked after the day-to-day business. Whatever explanatory or interpretative material was available was written by Alan Bowness, published in two very modest eight-page black-and-white leaflets. Modesty is perhaps the distinguishing characteristic of Hepworth's presentation in the years after her death. The visitor figures to the museum were never large, though those who went were extremely enthusiastic. In 1982 the Tate published a guide, in colour, by David Fraser Jenkins, to the gallery's collection of Hepworth at London and St Ives, expanding on Bowness's texts at St Ives. This was

59
Conversation with Magic Stones 1973, in the garden of the Hepworth Museum
Bronze, six pieces, edition of six
H. from 80 to 282 cm
Tate Gallery

the last book on Hepworth to be published by the Tate until the catalogue of the 1994 exhibition at Liverpool, and was also, apart from Margaret Gardiner's memoir, the only book to be published on her before Sally Festing's 1995 biography *Barbara Hepworth*.

One of the major policy initiatives in which the Tate Gallery was involved during the 1980s was adressing its regional responsibilities. The Hepworth Museum had, until this point, been little more than an anomaly. Now it took its place within a regional programme, and with the opening of the Tate Gallery St Ives in 1993, the Hepworth Museum acquired a new context. Now Hepworth was shown not only alone, but also in the company of other artists who had been associated with St Ives: Nicholson, Lanyon, Leach and, more rarely, among those artists who had once visited St Ives, such as the Americans Mark Tobey and Mark Rothko. The first curator of Tate St Ives, Michael Tooby, took responsibility for the Hepworth Museum, its first professional curator. In his introduction to the gallery guide of 1993 he characterised his aim for the new gallery as being to present a picture of 'modern art in the Cornish context' which 'will fracture and evolve'. The Hepworth Museum, however, where the possibility for change was necessarily more circumscribed, is presented, in contrast to the gallery, in a condition of relative stasis.

The foreword to the 1993 gallery guide reads that the Tate Gallery St Ives 'allows the visitor to see the works of art in the area in which they were conceived and close to the landscape and sea which influence them'. That this reading is appreciated by the general public is corroborated by the tremendous visitor figures at Tate St Ives. Hepworth herself certainly appreciated the sense of place, and of community, that St Ives offered her. On the other hand, one could argue that we do her a disservice in reascribing her to a St Ives school (and this has been a point of concern in relation to the whole premise of the museum at St Ives). The charm of St Ives, and of Hepworth's garden, should not lead us to a narrow interpretation of her sphere. Hepworth's rooting in a locality was interesting to her for its universalist potential, for offering an example in miniature of an individual's relationship to his or her wider society. We know from her correspondence that Hepworth's mind ran more on national and international matters – from her own showing in international exhibitions, to the work of the United Nations – than on local affairs. St Ives gave her the bedrock from which she worked outwards. Put simply, Hepworth was both local and international, and the two spheres existed in interdependence. This is not a problem peculiar to Hepworth; many of the St Ives artists were doing much the same thing and at the same time. Moreover, while painters like Davie, Heron, Frost and Lanyon were showing in New York, St Ives was increasingly a mecca for young British painters in search of some internationalism.

Hepworth was forward-thinking about her later reputation, and about the mechanisms and resources allowed to art history. Her concern coincided with her growing awareness of the interest in the 1930s, and may have been partly motivated by her wish to reinforce her own role alongside that of Nicholson, Moore and Read. However, she also had wider concerns at heart; now that British modern art was gaining historical respectability, she wanted to further its cause by making it possible for the Tate Gallery to establish an archive of twentieth-century art. In 1969 she suggested to Nicholson that he, she and Moore should bequeath their letters to the Tate, so that 'the main body of 1900s art would be in London'.

Hepworth's will confirmed that she had left '2 carvings, a copy of her book of

records and all correspondence of historical interest to the Tate Gallery'. Sir Norman Reid said: 'We had an agreement with Dame Barbara that she would pass on letters and catalogues as part of what is the history of modern art at the Tate.' As it turned out, Nicholson's papers were the first to arrive in the Tate Gallery Archive, while Moore's remained within the Foundation he had himself created. Despite Hepworth's hopes, Read's papers went to Canada, without there being an exchange with the Tate. While a small selection of archive material has been on display at the Hepworth Museum, a substantial part of Hepworth's own papers has only recently been deposited in the Tate Archive. The definition of what is of 'historical interest' will, inevitably, remain open to question. The fact that the more personal papers will remain in private hands may well mean that we continue to read Hepworth's life in its previous stream-lined fashion. Nevertheless, what is now available should encourage some new work on the artist.

Barbara Hepworth appointed four trustees of her estate: Anthony Lousada, her son-in-law Alan Bowness, Douglas Jenkins and Norman Reid. The connection with the Tate Gallery was reaffirmed, Lousada was a Tate trustee, Reid the then director and Bowness a future director, and they were all personal friends. Thus Hepworth is represented in St Ives by two nominally distinct, but in fact quite close and even overlapping spheres, the museological, and the estate. The museum has often benefited from the estate's proximity and collaboration. Estate-owned pieces are often on display there, and frequently lent to the Tate Gallery St Ives.

Part of the estate's business is to release, in a prudent fashion, works for sale. For a period after Hepworth's death, Marlborough Fine Art represented her estate, while her original gallery, Gimpels, continued occasionally to exercise an interest in the re-sale of works which came on to the market. They did this in collaboration with the New Art Centre, which has more recently been granted the business of the estate, in collaboration with Pace Wildenstein in New York. This move came after the 1994 retrospective had toured from Britain to Canada and America, and was launched in New York with a large selling exhibition of estate pieces, and an accompanying catalogue.

60
Four-Square (Walk-Through) 1966
Bronze, edition of three H.425.5 cm
Trustees of the Barbara Hepworth Estate

In terms of the current view of the artist, the hiatus in the literature in the 1970s and 1980s tended to reinforce an enclosed impression of her studio and garden. Until recently, Hepworth's *Pictorial Autobiography* was the only account of Hepworth's life. Its cast of characters was named, but not fully rounded. The majority of them are artists, named only once. Only her husbands, children and grandchildren, and perhaps Herbert Read emerge in any way as real people. Its effect may have been to stress the single-mindedness for which Hepworth has been reproached. Its impression is, however, quite misleading. Hepworth lived in a much wider world, a much more varied world, and was quite capable of sustaining a number of relationships, both long and short term, with a wider range of people.

One way of readjusting the story of Hepworth would be simply to find out more about some of the people who are mentioned briefly in the *Autobiography*, particularly those who were not artists and whose stories are less well known. Some – such as Marcus Brumwell, Priaulx Rainier (who helped to plant her garden), Duncan Macdonald (the director of the Reid and Lefevre Gallery and a great supporter), Norman Capener (the surgeon who operated on one of her daughters and with whom Hepworth developed a close professional-amateur artist relationship) and Nancie and Fred Halliday (to whom the

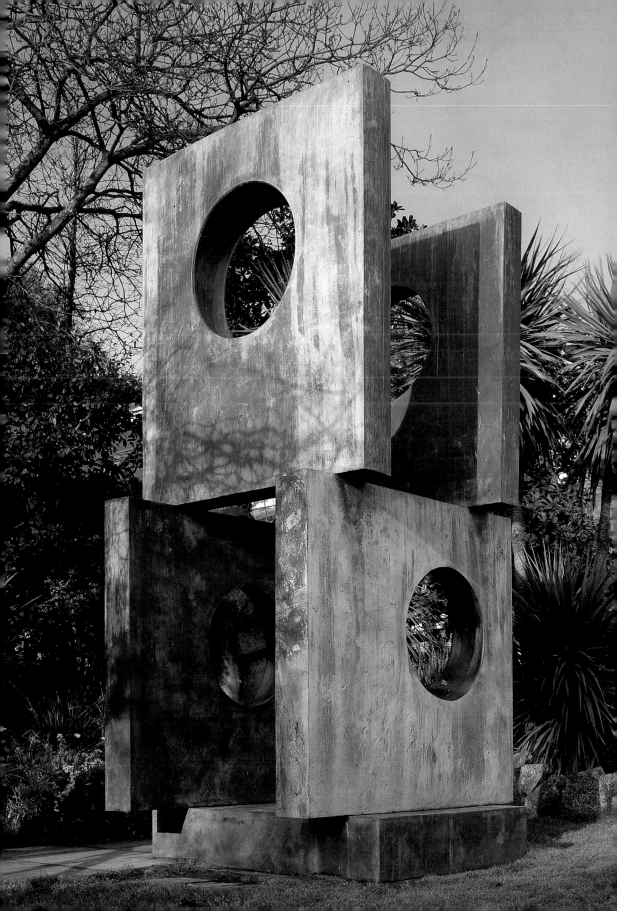

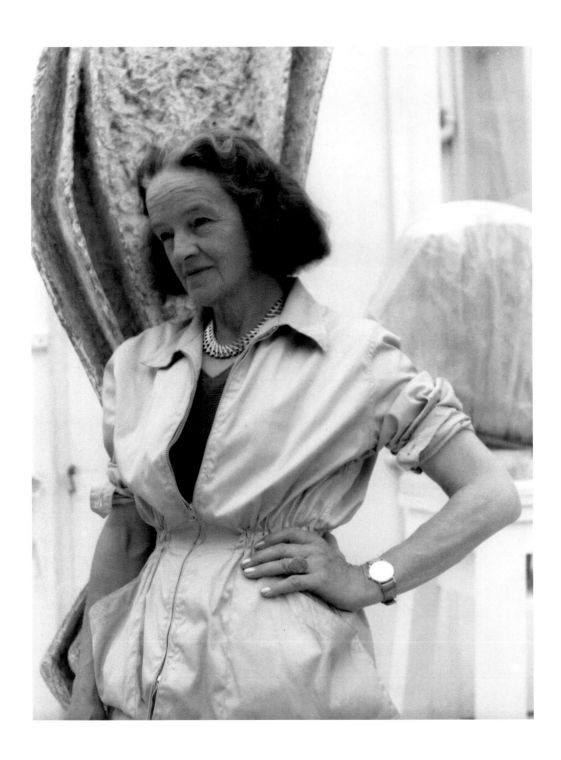

Autobiography is dedicated) – played important roles in supporting Hepworth emotionally and financially. Others who are even more clearly important to her life, notably Skeaping and Hammarskjöld, have only recently begun to be treated in greater depth. Different names, like that of E.H. Ramsden, have only just begun to emerge. Some names, well known in themselves (like that of Sir Norman Reid), are rarely fitted into Hepworth's story. Reid's role, in being a friend and an executor, is akin to the personal-professional roles played by Douglas Jenkins or Anthony Lousada, her accountant and her solicitor, or Lilian Somerville at the British Council who helped to shape her business life and profile. Many of these names are almost like vanished people, who need to be restored to her life.

In some ways it is probably true that Hepworth was on a kind of single track, occupied by her work, but even a cursory examination of her friends and their range of backgrounds shows that her story is rather more diverse. Hepworth's life is not simply about sculpture and her relationship with three men: Skeaping, Nicholson and Read. We could round it out by bringing in other disciplines. Music, for example, and her friendships with composers like Michael Tippett and Rainier, were very important to Hepworth. Topical concerns must also be given more emphasis. Hepworth was interested in political events, occasionally became involved in petitions or fundraising campaigns, and was affected by them. In the 1930s she joined the group For Intellectual Liberty, of which Margaret Gardiner was secretary, and after the war she became a pacifist and joined CND and the Labour Party.

Hepworth was not only interested in her own art, and that of her fellow pre-war modernists. She had a keen interest in what was going on in sculpture in the 1950s and 1960s – in Reg Butler, John Hoskin, Kenneth Armitage – and in contemporary painting. She had a rapport with Rothko, and with gestural abstraction. She was interested in writing and speaking, both her own and that of others. She listened to and criticised the way contemporary art was represented in discussions on the radio. Listening was the way she engaged in the debate from the distance of St Ives, and her contributions to radio programmes were vivid and revealing. She read widely in an effort to penetrate the meaning of her own sculpture, and art in general, more deeply, and discussed these writers, amongst them Rilke and Lorenz, with Read in their correspondence.

Far more is known of the outer life of Hepworth than of the inner life. The social dimension might be seen as a diversion from the 'central' matter in hand, the work, but we cannot be sure until we know what else might be taken into account, and it may be particularly necessary in this very case to bring out Hepworth as an affective and involved individual, who neither closeted herself away in St Ives, nor only thought about her carving. It is intriguing that someone who used autobiography as a way of communicating throughout her life should tell us so little. However, what she tells us is consistent, like a motif repeated in an artistic oeuvre.

In his introduction to *Barbara Hepworth Reconsidered* (1996) David Thistlewood goes some way to explaining how and why Hepworth seemed either old-fashioned, irrelevant, or simply derivative to a British art world that was being increasingly exposed to more comprehensive accounts of modernism and Constructivism. This may explain why no new research was published on her in the twenty-five years after 1970. Her *Pictorial Autobiography* could only have confirmed this impression, harking back as it did to pre-war ideas, as if their absolutist standards still applied.

Perhaps British writers and art historians have been over-concerned with Hepworth's position, her context, and the question of which archive papers one could or could not see, what one did or did not know. We get further by looking at what is there, than dwelling on what isn't. To take a vivid example, an American writer, Anne Wagner, has paid close attention to a single text, the *Spectator* review of 1933 by Adrian Stokes, and its relationship to Hepworth's carvings. (Unfortunately, one of the works in question – which is an unusual one for Hepworth because the 'smaller form' or 'baby' is unusually large in relation to its 'mother' – is believed to have been destroyed in the war.) Wagner's readings of Stokes show both how Stokes's writing helps us to understand Hepworth, but cannot encompass it. Stokes's carving theory has the carver as male, the stone block as female. The carver engenders life in the stone by endless rubbing. While this accords with Hepworth's avowed pleasure in 'resistance', it becomes awkward to ascribe genders to maker and material. Though Stokes introduces a moment of mothering into his narrative of carving, the child – the product – becomes male, like its 'father'. Hepworth generally side-stepped questions of gender, but addressing this issue will help us to think better about Hepworth. Anne Wagner has looked at Hepworth in relation to nurture and to child-rearing, not only in comparison to Moore, but also more widely to the climate at the time.

Hepworth's letters to E.H. Ramsden (fig.63) interestingly show how she compared her stance on gender to Ramsden. Ramsden maintained a public profile as a putative man, hiding her female identity by means of her initials, but Hepworth's own strategy was rather not to adopt any public stance. Looking at gender and what it meant to Herbert Read – how his reading of the gender

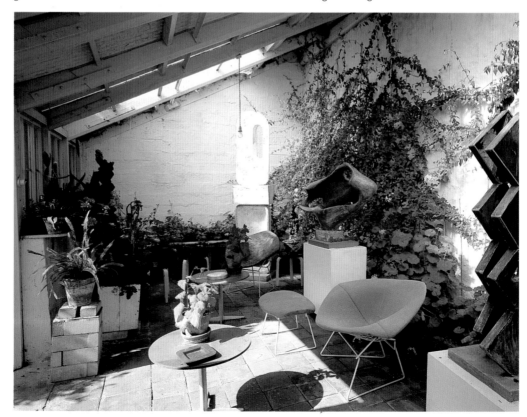

split between Moore/Hepworth was informed by his reading of that split as vitality/loveliness – helps us to clarify his differing treatment of the two artists. It seems that Hepworth understood better than Read the theoretical, rather than the actual, distinction between the feminine and the masculine points of view, and their complementary nature. Other pieces of received wisdom, which are little more than value judgements, may well arise from such discrimination. Why have people decried Hepworth's later work as too large, too monumental? Nothing is inherently wrong with scale, but are these later pieces read as being too large for a woman whose special gift is traditionally considered to be a delicate touch?

62 *left*
The upper studio/sun-
room in the garden of
the Hepworth
Museum at St Ives

63
E.H. Ramsden, *c.*1950

Stokes wrote well on Hepworth; exceptionally well. One could say that his text was only waiting to be used afresh. What will come next? Wagner's treatment involved not so much feminism as psychoanalysis, though perhaps more important than any methodology was simply the ability to see afresh. Nevertheless, it seems likely that psycho analysis – especially given Hepworth's closeness to Stokes and Read, and thus to an informed understanding of formal psychoanalysis – will prove particularly useful in helping us to understand Hepworth in more illuminating ways than a more simplistic feminism will allow us. However, feminism allows us to identify and celebrate what is particular to Hepworth, whereas she was fatally compromised by seeking recognition on equal terms. New analyses of Stokes – and indeed of Read – suggest not only that Hepworth's brand of carving forced the male critics to modulate their theories, but also that, though they recognised that something deeply symbolic was present in her work, they were ultimately unable, or unwilling, to absorb it into their critical position.

If this is true, and I believe it is, it throws out a challenge to a new generation of critics and writers. Hepworth has now been definitively detached from Moore, Nicholson and Gabo. Discussion must now centre on her own terms, and what they meant. We no longer need to talk in terms of comparison and precedence. The discussions about who first put the hole or the string into the sculpture have not so much been settled, as proved to be irrelevant. Hepworth studies promise to be in a state of flux for some time.

To attempt to understand Hepworth necessarily involves placing her sculpture within its wider context, for to her way of thinking the one depended on the other. Her words about Dag Hammerskjöld are revealing, for they show precisely how the two spheres run together: 'Knowing how Dag was thinking about world ideas and about ideas in sculpture.' Hepworth's sculptures should be understood as her idea of what was fit for the time, her appropriate responses. They were not so much a barometer of the world outside, but a filter, through which she absorbed what she could salvage as 'good'. Sometimes she had to struggle to 'keep the good idea', but saw the proof of the strength of her mental image in the physical form of the sculpture. This 'beautiful thought' was Hepworth's way of dealing with life. Hepworth's whole world view was intimately connected to her awareness of whether she was the subject or the object, 'the spectator of the object or the object itself'. Her conscious deployment of these two ways of looking and being is played out not only in her works, but in her use of autobiography to talk about herself and her work. Where this leaves

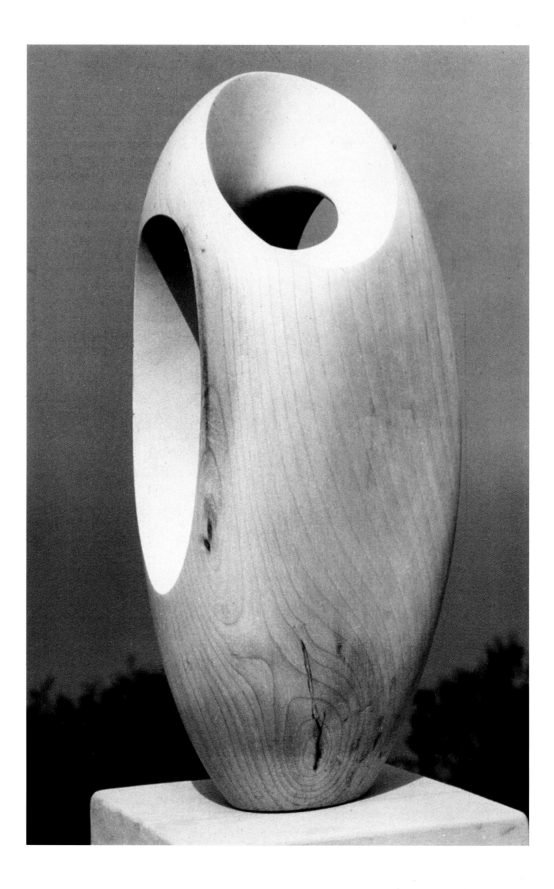

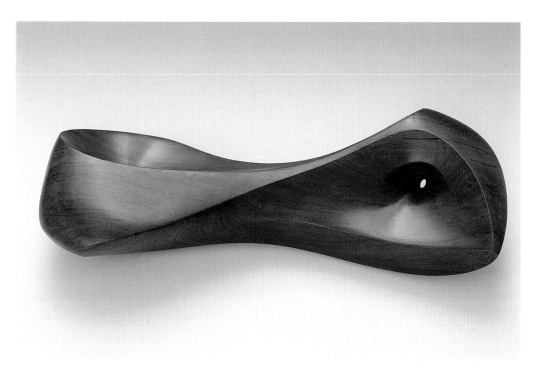

us, and our relationship with her work, is complicated, but I will end with an attempt at simplification.

It may be the 'beautiful thought', and the thought's affiliation with the line, which enables us to to retain a mental image of a work by Hepworth, just as she had wished to maintain the thought in her own mind. There is a linearity in Hepworth's work which is quite different to the volume of Moore. Her lines describe a volume, her volumes describe a line. This linear quality provides a continuum through most of her work, although there is a shift in the sculptor's own physical involvement. In later life Hepworth was the spectator, wanting her sculptures to interact with her look, as in earlier years she had been the sculpture, feeling its position and feeling the way that it was worked.

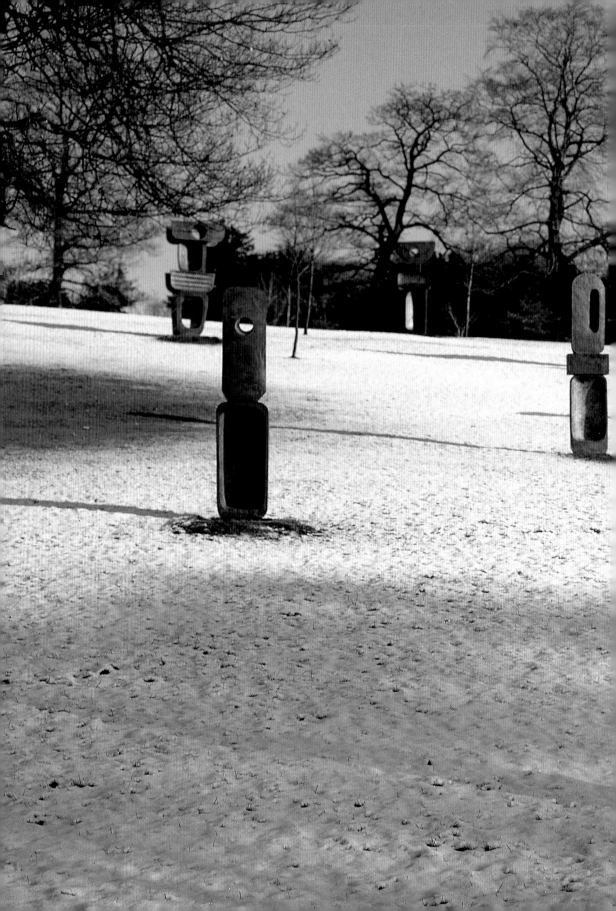

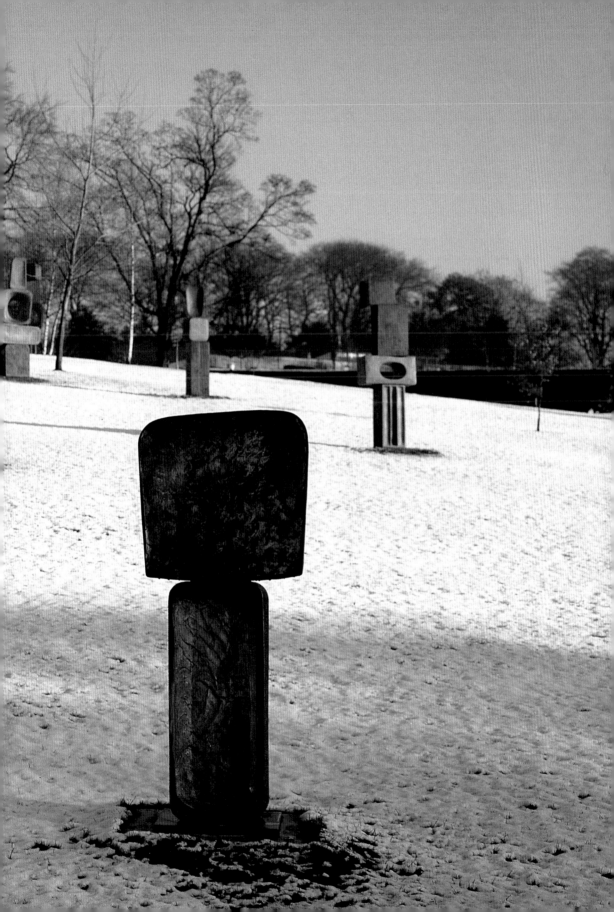

Selected Bibliography

Quotations from Barbara Hepworth's letters are taken from the Herbert Read Archive at the university of Victoria, Canada, and Ben Nicholson's papers at the Tate Gallery Archive.

Most of the significant writings on Hepworth are mentioned in the text of this book, and full details about their place and date of publication, as well as those of many others, can be found in the extensive bibliography compiled in 1994 and published in 1996 in *Barbara Hepworth Reconsidered* by Liverpool University Press and Tate Gallery Liverpool. This bibliography was compiled by Meg Duff of the Tate Gallery Library and includes over 700 items, divided into seven sections:
1 Monographs
2 Writings by the artist
3 Selected books, containing articles or references
4 Solo exhibition catalogues
5 Group exhibition catalogued
6 Articles from periodicals
7 An index of authors and editors

Although now out of print, the following three books remain the basic tools of Hepworth studies:

Barbara Hepworth: Carvings and Drawings, with an introduction by Herbert Read, London 1952

HODIN, J.P., *Barbara Hepworth,* with a catalogue of works by Alan Bowness, London and Neuchatel 1961.

BOWNESS, Alan (ed.), *The Complete Sculpture of Barbara Hepworth 1960–1969,* London 1971

The 1961 and 1971 books make up the existing concise catalogues of Hepworth's oeuvre: the former volume lists works from 1925 to 1959–60, the latter completes the list to 1969. Though the catalogue entries are largely out of date they still represent the best available inventores. Both books also include bibliographies.

Of books which are still in print, the following offer personal accounts of Hepworth's life:

Barbara Hepworth: A Pictorial Autobiography, 1970

GARDINER, Margaret, *Barbara Hepworth: a Memoir,* Edinburth 1982. This is an account of Hepworth in the 1930s, written by one of her closest friends in that period.

The chronology compiled by Jeremy Lewison for the exhibition catalogue *Ben Nicholson*, Tate Gallery, Oct. 1993 – Jan 1994, is also extremely helpful for Hepworth, principally between 1931 and 1951.

More substantial overviews of Hepworth's work can be found in:

Barbara Hepworth: A Retrospective, Liverpool and Ontario 1994, with essays by Penelope Curtis and Alan Wilkinson, and a concise chronology of Hepworth's public commissions by Penelope Curtis.

THISTLEWOOD, David (ed.), *Barbara Hepworth Reconsidered*, Liverpool 1996, with essays by eleven contributors.

Meg Duff's bibliography includes publications up to 1994. Material which has been published since includes:

CURTIS, Penelope, 'Hepworth, Moore and Nicholson 1934–39: L'imagination picturale', in *Un Siècle de sculpture anglaise*, exh. cat., Jeu de Paume, Paris, June–Sept. 1996

WILKINSON, Alan, *Barbara Hepworth*, exh. cat., Wildenstein, New York, Oct.–Nov. 1996

CURTIS, Penelope, 'The Landscape of Barbara Hepworth', *The Sculpture Journal*, II, London 1998, pp.106–112

WAGNER, Anne Middleton, 'Henry Moore's Mother', *Representations*, No 65, 1999, pp.93f

BOOTH, John B., 'Window on the Ear: Barbara Hepworth and the Fenestration Series of Drawings', *The Journal of Laryngology and Ontology*, Vol. 114, April 2000, Supp. 26, pp.1–29

CHECKLAND, Sarah Jane, *Ben Nicholson: The Vicious Circles of his Life and Art*, London 2000

GALE, Matthew and STEPHENS, Chris, *Barbara Hepworth: Works in the Tate Collection and the Barbara Hepworth Museum St Ives*, London 2001

Photographic Credits

Copyright Credit

Photo: © James Austin 51

© Alan Bowness, Hepworth Estate frontis (Photo: Peter Kinnear); 16; 18 (Photo: Valerie Wilmer); 31, 41; 44 (Photo: A.D.G. Heath); 56, 61, 64

Photo: © Alan Bowness, reproduced with the kind permission of the Trustees of the Ulster Museum Belfast 39

The Bridgeman Art Library 45, 54

Courtesy Jonathan Clark & Co, London (Photo: Miki Slingsby) 13

Conway Library © Courtauld Institute 2, 3, 4, 21, 27, 52

Photo: Prudence Cuming Associates Ltd, courtesy of Agnews 11

Photo © Gimpel Fils, London 40 and front cover

The Barbara Hepworth Museum and Sculpture Garden 14

Israel Museum, Photo: Yoram Lehmann 65

Photo: University of Leeds Audio-Visual Service 49

Photo courtesy of Marlborough School, St Albans 38

Photo: © 1997 The Museum of Modern Art, New York 53

Photo: Norfolk Museums Service (Norwich Castle Museum) 47

Norton Simon Art Foundation, Pasedena, CA 50

Art Gallery of Ontario (Photo: Larry Ostrom) 5

Pier Arts Centre, Stromness, Orkney 1, 25, 26, 32, 37, 42 (Photos © PAC/RW)

Photo: © Graham Portlock 15

Private Collection 9, 33, 48

Courtesy of the Estate of E.H. Ramsden 63

Tate Gallery Archive 6 (Photo: Hans Erni); 7, 8, 10, 34, 35

Tate Gallery (Photos: Marcus Leith, Marcella Leith, David Lambert) 12, 17, 20, 24, 28, 30, 36, 43, 46, 57, 58, 59, 60, 62

UN Photo 161,123 by Nicholas Kuskin 19

Wakefield City Art Gallery 23, 29

Frederick R. Weisman Art Museum 55

Whitworth Art Gallery 22

Yorkshire Sculpture Park (Photo: Jerry Hardman-Jones) 66

Index

Titles of works make
reference to the text and
therefore may not be given
here in full.

79